Artists in Focus

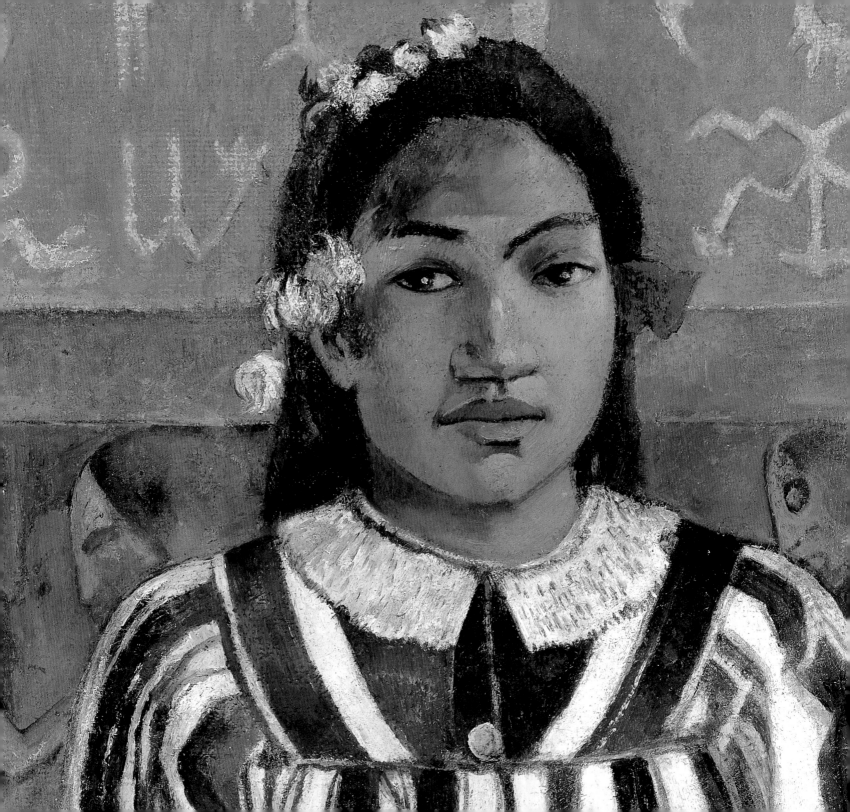

Gauguin

Britt Salvesen

in association with

Douglas W. Druick and Peter Kort Zegers

THE ART INSTITUTE OF CHICAGO

Distributed by Harry N. Abrams, Inc., Publishers

Produced by the Publications Department of The Art Institute of Chicago, Susan F. Rossen, Executive Director
Edited by Lisa Meyerowitz and Susan F. Rossen
Photo editor, Karen Altschul
Production supervised by Sarah Guernsey and Stacey Hendricks

Designed and typeset by Joan Sommers Design, Chicago
Color separations by Professional Graphics Inc., Rockford, IL.
Printed and bound by Mondadori, Verona, Italy

Distributed in 2001 by Harry N. Abrams, Inc.,
100 Fifth Avenue, New York, NY 10011

Library of Congress Catalog Card Number 200189786

ISBN 0-8109-6739-1

Photography, unless otherwise noted, by the Imaging Department, Alan B. Newman, Executive Director

All illustrations are of works by Paul Gauguin in The Art Institute of Chicago, unless otherwise noted. Dimensions of works of art are given in centimeters, height preceding width.

Fig. 1: © 2000 Malcolm Varon. Fig. 2: © Musée Départmental Maurice Denis "Le Prieuré," St.-Germain-en-Laye. Figs. 3, 20: photos by Michael Bodycomb. Fig. 5: © Board of Trustees, National Gallery of Art, Washington, D.C. Fig. 7: RMN/Art Resource, NY. Fig. 8: Musées Royaux d'Art et d'Histoire, Brussels. Figs. 10, 13: Van Gogh Museum, Amsterdam (Vincent van Gogh Foundation). Fig. 11: The Bridgeman Art Library. Fig. 12: National Galleries of Scotland, Edinburgh. Fig. 14: The State Hermitage Museum, St. Petersburg. Fig. 15: Israel Museum Collection, Jerusalem. Fig. 16: From *Oudheden van Java: De tempel ruïne Boro-Boedoer* (Batavia, 1874), pl. 57/58. Fig. 17: © 2000 Museum of Fine Arts, Boston. All rights reserved. Fig. 19: From J. Arago, *Voyage autour du monde* (Paris, 1839), vol. 2, p. 327. Fig. 21: Photo by Joe Mikuliak. Fig. 22: From Ronald Pickvance, *Gauguin*, exh. cat. (Martigny, Switzerland, 1998), p. 148. Fig. 23: Photo by Jean Schormans, RMN/Art Resource, NY. Fig. 24: Cleveland Museum of Art. Fig. 25: Galerie Schmit, Paris. Fig. 27: Witt Library, Courtauld Institute, London.

Cover: *Day of the God*, 1894 (pl. 16).
Details: frontispiece (see pl. 13), p. 8 (see pl. 29), p. 13 (see pl. 3), p. 21 (see pl. 6), p. 27 (see pl. 11), p. 35 (see pl. 13), p. 41 (see pl. 16), p. 49 (see pl. 16), p. 55 (see pl. 17), p. 61 (see pl. 18b), p. 67 (see pl. 25), p. 71 (see pl. 8), p. 106 (see pl. 31)

Contents

Foreword

To fully understand the scope and originality of Paul Gauguin's art, one must look not only at his output of paintings, but also at the works he created in a range of media, including printmaking, ceramics and sculpture, and drawing. Gauguin eagerly embraced the unconventional in art, as in life, and through constant experimentation, he achieved great innovation and powerful expression. In fact the first works by Gauguin to enter the permanent collection of The Art Institute of Chicago—both in 1922—were not paintings but a haunting watercolor (*Mysterious Water [Papa moe]*) and a bold, late print (*Nativity*). One year after these gifts, the museum acquired its first canvas by the artist, *Hibiscus Tree (Te Burau)*, painted during his initial trip to Tahiti. Always a restless soul, Gauguin journeyed to the South Pacific to escape the constraints and materialism of Europe and to live and depict a more essential, "primal" existence. The most recent addition to

the collection, made in 2000, is an early still life, produced when Gauguin was still teaching himself to capture appearances, rather than the mysteries that underlie them, as he would later challenge himself to do. Over the nearly eight decades that separate these acquisitions, the Art Institute's collection of works by Gauguin has developed into one of the most important in the United States, including examples from every period of this prodigious artist's career: eight canvases, over 180 works on paper, and a ceramic sculpture.

Like the other *Artists in Focus* titles—the Art Institute's ongoing series that showcases key modern artists who are particularly well represented in the museum's permanent collections—*Gauguin* (along with a similar volume on van Gogh), is occasioned by a major loan exhibition. "Van Gogh and Gauguin: The Studio of the South," which opens at the Art Institute in

September 2001 and then travels to the Van Gogh Museum, Amsterdam, in February 2002, affords us the opportunity to celebrate Gauguin's significant presence in the Art Institute. This book draws upon the prodigious scholarly study of the collection and of the life and work of Gauguin by Searle Curator of European Paintings and Prince Trust Curator of Prints and Drawings, Douglas W. Druick, and Rothman Family Research Curator Peter Kort Zegers, which began in 1988 with the exhibition "The Art of Paul Gauguin," co-organized with the National Gallery of Art, Washington, D. C., and the Musée d'Orsay, Paris, and culminates with their work on van Gogh and Gauguin in Arles.

In writing the catalogue for "Van Gogh and Gauguin: The Studio of the South," Messrs. Druick and Zegers have worked closely with Britt Salvesen, Associate Editor in the Publications Department and a scholar of nineteenth-century art. She has contributed to a special issue of the Art Institute's journal, *Museum Studies*, entitled *Songs on Stone: James McNeill Whistler and the Art of Lithography* (1998), and edited and wrote much of a recent publication, *Impressionism and Post-Impressionism in The Art Institute of Chicago* (2000). We are grateful to Ms. Salvesen for her concise and elegant text on Gauguin, whose dedication to expanding the limits of representation continues to influence our ideas about art and the role of the artist in society.

James N. Wood, Director and President
The Art Institute of Chicago

"Y ou wish to know who I am," wrote Paul Gauguin near the end of his life, "my works are not enough for you." With this statement, directed at both his contemporaries in France and at posterity, Gauguin raised an issue central to the history of modern art: the relationship between an artist's life and work. By the end of the nineteenth century, an active market for contemporary painting and sculpture had developed, ironically fueled in part by the notion that creative inspiration was independent of commercial imperatives. If art was to serve as an antidote to or escape from urban, industrialized society, its makers had to assert their access to a deeper reality and render it through expressive rather than descriptive forms, colors, and compositions. Intentionally producing a mysterious, multivalent art, and adopting a rebellious, bohemian persona, Gauguin courted the notoriety that he sometimes claimed to resent.

Indeed, Gauguin's legend must be understood as one of his most original creations, existing alongside his extraordinary output of paintings, drawings, sculptures, ceramics, and prints. We do wish to know about his life as well as his work, because in both he negotiated a set of concerns—creativity and ambition, decadence and renewal, individuality and universality—that hold continued relevance for our own time.

Eugène Henri Paul Gauguin was born in Paris in 1848, the second child and only son of Clovis Gauguin, a political journalist, and Aline Chazal, whose mother was the radical feminist author Flora Tristan. The following year, Clovis Gauguin, already ill, suffered a ruptured aneurysm and died while traveling with his family to Peru, where his wife had relatives. Aline and the children, Paul and Marie, stayed in Lima with Aline's wealthy and influential great-granduncle for four years. They returned to France in 1854, settling first in Orléans and then in Paris, where Aline worked as a seamstress. Paul was a difficult teenager and an indifferent student, seemingly unwilling to dedicate himself to anything other than fencing at the rigorous Jesuit seminary he attended. He half-heartedly prepared to enroll at the naval academy, but for reasons that are unclear, he failed to take the entrance examinations. In 1865, at age seventeen, he enlisted as an officer's candidate in the merchant marines and immediately embarked on a fifteen-week voyage to Rio de Janeiro, Brazil. For the next five years, Gauguin sailed around the world, first with the merchant marines and then with the French navy. Like many sailors, he mastered manual skills, undoubtedly passing the long hours of inactivity on board ship enjoying easygoing male camaraderie and engaging in traditional seamen's handicrafts such as carving and decorating tools and utensils. While it would be an exaggeration

to say that the young man had already found his artistic vocation, the older Gauguin would actively embrace the identity of a rough sailor, self-sufficient and wayfaring.

When war broke out between France and Prussia in 1870, Gauguin was a crew member on a scientific mission to the Arctic Circle led by Prince Jérôme Napoleon (known as "Plon-Plon"), a cousin of Emperor Napoleon III. It would be Gauguin's last naval voyage; early the following year, he was released from military service. The home he had left behind no longer existed: his mother had died in 1867, willing some money to Paul and Marie and placing them under the legal guardianship of Gustave Arosa, a family friend in Paris. An affluent businessman with antiquarian interests, Arosa was involved in pioneering new techniques for the photographic reproduction of artworks. Through Arosa, Gauguin obtained a job in a brokerage firm; and at the Arosa family home, he made the acquaintance of Mette Gad, the Danish woman who became his fiancée. Moreover, Arosa's passion for art—his library of art publications; his collection of ceramics; and his canvases by Corot, Courbet, Daumier, Delacroix, and Jongkind—encouraged Gauguin to take up painting in the months before his wedding.

Emerging Artistic Ambitions

Gauguin married Mette in November 1873. He had turned twenty-five in June; she was twenty-three. Over the next ten years, they had four sons and a daughter. Gauguin took evident pleasure in his domestic life, as is reflected in the drawings he made of Mette and each of their children. From quick sketches to more finished studies, Gauguin's portrayals of his family are intimate, tender, and often remarkably observant. In a portrait of his fourth child, Jean René (executed in 1881, the year of his birth) (pl. 1) for example, Gauguin used pen and ink, softened by wash and red chalk, to capture the infant's mute alertness and almost poignant delicacy. In this early work, Gauguin attempted to gain empathic access to another state of consciousness through the act of drawing what he saw. Drawing was central to Gauguin's practice, as it would remain in Brittany, Martinique, and Tahiti.

Gauguin's sketches, watercolors, and sculptures of his family members testify to his growing artistic ambitions, which were fostered by his acquaintance with critics, sculptors, and notably the Impressionist painter Camille Pissarro, another connection made through Arosa, who had begun acquiring the artist's work in the early 1870s. When Pissarro rented an apartment in Paris in late 1878, he and Gauguin became

friends. Over the coming years, Pissarro, eighteen years Gauguin's senior, served as his teacher, mentor, and principal connection to the Parisian avant-garde. Devoting Sundays and vacations to his painting, Gauguin often visited Pissarro in the country towns where he and his family lived. In return for informal artistic instruction, Gauguin lent Pissarro material support; now earning a comfortable living at the stock exchange, he began collecting Pissarro's work and recommending it to his business colleagues.

Gauguin loaned three of his Pissarros to the fourth Impressionist exhibition, held in Paris in the spring of 1879. The show marked an end-point for some members of the group—such as Claude Monet and Pierre Auguste Renoir, who were discouraged by consistently poor sales and began to explore other venues—but for Gauguin it was a beginning. Invited at the last minute by Edgar Degas and Pissarro, Gauguin showed a marble bust he had carved of his firstborn son, Emil (1879; The Metropolitan Museum of Art, New York) and perhaps some paintings as well. Entered too late to appear in the catalogue, Gauguin's contributions went unremarked by most critics, but his commitment to art was growing stronger. His collecting activity increased, with acquisitions of works by Paul Cézanne (see fig. 1), Degas, Edouard Manet, and Renoir; he painted and exhibited more, appearing in the

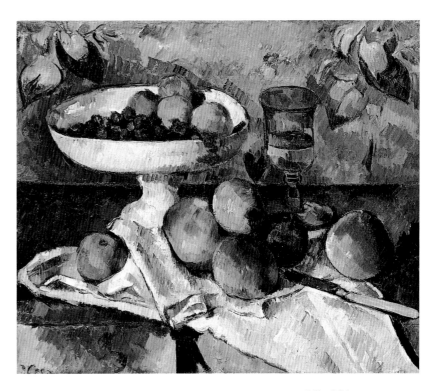

1. Paul Cézanne (French; 1839–1906). *Still Life with Fruit Dish*, 1879–80. Oil on canvas; 46 x 55 cm. Private collection.

fifth, sixth, and seventh Impressionist exhibitions, held in 1880, 1881, and 1882, respectively. While his canvases of this period attest to the influence of Pissarro as well as of Degas, the few wooden sculptures he also made reveal a more rugged individuality. In this medium, Gauguin seemed less dependent on immediate, fine-art models, able instead to draw upon other representational traditions and perhaps even his earlier shipboard whittling. These carvings display a roughness characteristic of what was considered "primitive" or archaic art, and begin to suggest the direction his art—and his persona—would take in coming years.

The Faun *speaks to Gauguin's fantasies of reinventing himself as a bohemian artist, full of creative energies and in touch with primal urges.*

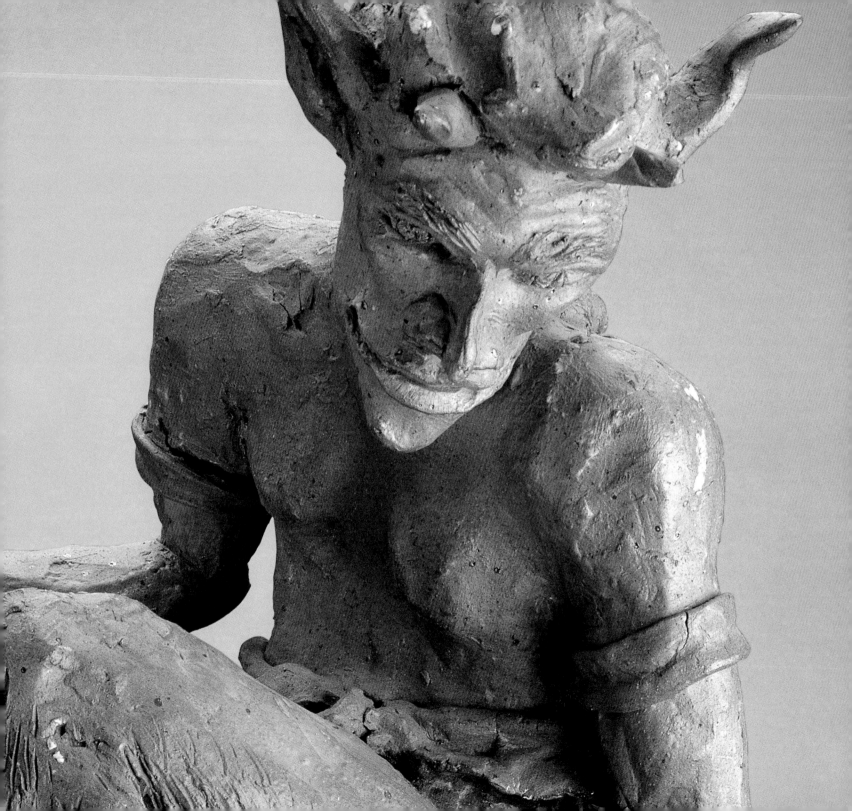

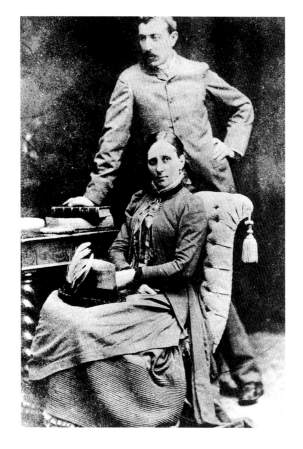

2. *Mette and Paul Gauguin in Copenhagen,*1885. Photograph. Musée Départemental Maurice Denis "Le Prieuré," St.-Germain-en-Laye.

Gauguin greatly admired the so-called folk arts and handicrafts. He decorated his home with textiles, ceramics, and various objects made of wood and metal, which feature in turn in his paintings. In a still life of 1880 (pl. 2), Gauguin brought together a rootwood tankard of Norwegian origin, a striped textile that was probably North African, and a dented pewter jug. The reappearance of these objects in other pictures and in photographs documenting Gauguin's various homes indicates that they held special significance for him. Here, he rendered them with the feathery brushwork of Impressionism, employing a pleasing, blonde palette, but displaying neither the virtuoso handling nor the decorative appeal that would have made this work attractive to the market. The deliberately clumsy arrangement of the elements raises the possibility that Gauguin intended a commentary of some sort. Viewed as expressive caricatures, the unevenly matched vessels form an odd pairing, the tankard's heavy solidity contrasting with the jug's lithe curves. Perhaps, they are surrogates for Gauguin and his Scandinavian wife, who were beginning to experience marital tensions. The outcome of this confrontation is not clear in the painting, but it soon would be in life.

Gauguin felt increasingly frustrated by his inability to devote himself fully to art. The stock market itself determined a resolution to his situation. It collapsed in early 1882, and by the end of 1883, Gauguin was out of a job. In December Mette gave birth to their fifth child, named Clovis after Gauguin's father. On the boy's birth certificate, Gauguin boldly listed his profession as "artist-painter." Unfortunately, the financial crash proved disastrous for the art market. It was an inopportune time for a virtual unknown to attempt to support a large family on an income earned from painting. The Gauguins' comfortable existence seemed to have come to an end.

In January 1884, the family moved to Rouen. Pissarro had worked there the previous autumn, and Gauguin optimistically expected that he would be able to live more cheaply and sell paintings more readily in the northern city than in Paris. He quickly learned otherwise. By the spring, he was attempting to sell some of his art collection; in the summer, he cashed in his life insurance policy at a fifty percent loss; in October Mette left with two of the children to live with her family in Copenhagen; the following month, Gauguin joined them (see fig. 2), having taken a job as salesman for a French canvas manufacturer.

Gauguin was miserable in Denmark. Mette put her knowledge of French to work, giving private lessons and translating. By contrast Gauguin made not the slightest headway as a salesman, and he was well aware that his wife's family and social circle, which included some of the brightest and most admired Danish artists and intellectuals of the day, considered him to be a failure.

It was a time for soul-searching, as a somber self-portrait of 1885 (fig. 3) reveals. Gauguin depicted himself as a painter in a garret, seated, brush in hand, before his easel, uncertainly scrutinizing his image in the mirror. His cramped posture vividly evokes his suffocating depression, while his piercing gaze attests to firm resolve. He confided his troubled state of mind

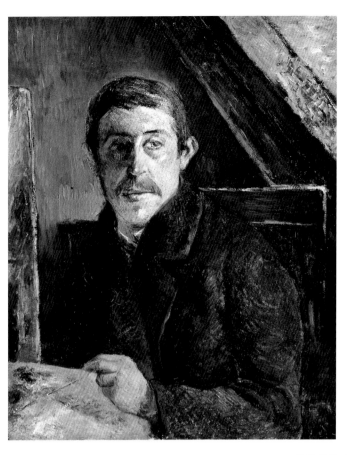

3. *Self-Portrait in Front of an Easel,*1885. Oil on canvas; 65 x 54 cm. Kimbell Art Museum, Fort Worth, Texas.

15

to Pissarro: "I am more than ever obsessed with painting—so much so that financial worries and the need to attend to business can no longer keep me from it." Frustrated though he was, the rejection in his wife's native land seemed to help him to crystallize his ambitions. In Rouen he had begun to write a manifesto of sorts, entitled "Synthetic Notes" ("Notes synthétiques"), in which he described daring effects of pure color and decorative line that had yet to appear in his paintings. In effect he began to imagine the

direction his art might take in advance of his powers to achieve it.

In June 1885, Gauguin returned to Paris, along with Clovis. (The boy lived with his father only a short while, however, later attending boarding school and then rejoining his mother in Copenhagen.) Despite intentions to the contrary, the Gauguins would never again be reunited as a family. Paul and Clovis experienced a terrible winter, during which the child came down with smallpox, and his father was forced to take a job as a bill poster. In the spring, the eighth—and last—Impressionist exhibition gave Gauguin the opportunity to present his work to the public. Although he had not been very productive in the difficult months leading up to the exhibition's mid-May opening, Gauguin showed some nineteen paintings as well as one wood relief carving. But his hopes for success proved false. Not only were his works reviewed tepidly, but they were completely overshadowed by Degas's remarkable series of pastels featuring bathers and by the astonishing contribution of twenty-six-year-old newcomer, Georges Seurat. Seurat's *Sunday on La Grande Jatte—1884* (1884–86; The Art Institute of Chicago), monumental in scale and radical in style and technique, announced a break with classic Impressionism and opened up new directions for vanguard painting. Younger artists acknowledged Seurat as the leader of a new movement, Neo-Impressionism, which Gauguin contemptuously dismissed as "petit point." When even his longtime mentor, Pissarro, became a disciple, however, he had to admit that changes in the art world were about to leave him behind, without connections to critics, dealers, or other artists.

Difficult as this dilemma was to face, the more immediate crisis was financial. Desperate for money, Gauguin was gratified when the printmaker Félix Bracquemond, who had exhibited with the Impressionists, purchased one of his paintings for a good price. Perhaps more importantly, Bracquemond suggested that Gauguin try his hand at ceramics to widen his market possibilities, and introduced him to the ceramist Ernest Chaplet. Chaplet was engaged in the rather profitable business of manufacturing decorative vases, throwing pots to which artists added glazed designs or decorative elements. Gauguin responded enthusiastically, doubtless recalling Arosa's important ceramics collection, and eager as well for a change in aesthetic direction. In June 1886, he boasted to Mette that Chaplet "loved my sculpture" and that he would surely make a profit from this "great resource."

Until this time, Gauguin had explored divergent paths in his sculpture: he first created highly finished works in marble (the medium

associated with antiquity and high art), but subsequently preferred wood; this material, predominant in folk art, allowed him to achieve rough-hewn effects. Working in clay suggested another set of traditions and associations, which are reflected in what may well be the first piece that Gauguin made in Chaplet's studio: *The Faun* (pl. 3), an exceptional work in Gauguin's oeuvre that marked a turning point in his life and career.

In ancient Greek mythology, fauns, satyrs, and the god Pan symbolize nature, free sexuality, and unbridled lust. They are usually depicted as hybrid beings, ranging from figures who are almost completely human, but who sport goat ears and a pair of small horns, to creatures who are equal parts animal and human. The satyr's darker, sexual aspects took on new meaning when seen through the lens of Charles Darwin's theories of evolution. Half man and half beast, the classical creature represented early man, emerging from the animal realm. In the 1880s, ambivalence toward modernity helped fuel nostalgia for the uninhibitedness, intuitiveness, sensuality, and rich imaginative connection with the world that was attributed to primitive man. For example, in the work of sculptor Auguste Rodin, the satyr emerges as a force of nature, the embodiment of erotic and creative energy that seemed increasingly difficult for people to achieve in the modern, industrialized world.

4. Eugène Delacroix (French; 1798–1863). *Mephistopheles* (detail),1828. Lithograph; image 21 x 28.5 cm. The Art Institute of Chicago, The John H. Wrenn Memorial Collection, 1930.1261.

Gauguin's satyr, by virtue of its physiognomy, also relates to the somewhat earlier tradition of Romantic demonic imagery, notably Eugène Delacroix's 1828 lithographic images of Mephistopheles (see fig. 4). Yet *The Faun* exhibits none of Mephistopheles's intensity and passion. Its expression is somewhat doleful and distracted; a single figure, it is neither involved with fellow revelers nor engaged in amorous pursuits. It holds a horn, in keeping with the faun's pastoral identity, but the instrument does not double as a phallic symbol, as is often the case. Past its prime, bereft of virility, Gauguin's *Faun* perhaps suggests the artist's experience of change and loss. Although the decisions that were bringing his relationship with Mette to an end were entirely his own, Gauguin long nursed feelings of resentment at what he considered her

coldness and tendency to side with her family against him; he also apparently feared she would be unfaithful to him. The faun's features suggest a mocking rendition of Edvard Brandes, a member of Mette's social circle who was the lover (and later husband) of Mette's sister Ingeborg, recently divorced from the painter Fritz Thaulow. A sly caricature of Brandes, the face contains elements of self-portraiture as well, its lecherous aspects overshadowed by an aura of melancholy and impotence.

At the same time that *The Faun* signaled, perhaps, the end of his marriage, it also speaks to Gauguin's fantasies of reinventing himself as a bohemian artist, full of creative energies and in touch with primal urges. Artistically, this identity would set him apart from the "scientific" Neo-Impressionists; personally, it would free him from the encumbrances of bourgeois responsibility.

Brittany, Martinique, and Arles, 1886–91

Unable to thrive in Paris, Gauguin decided to settle in Brittany; one of the poorest regions of France, it was, he informed Mette, the cheapest possible place to live. For the past two decades, Brittany had been the site of a bustling, international artists' colony centered in the town of Pont-Aven. Gauguin stayed in the popular Pension Gloanec in the summer of 1886. Fortuitously, he found Brittany's artistic climate

nurturing; in the context of a group of aspiring painters, most of them foreign, his talent appeared more remarkable and he was accorded more respect than in Paris.

Although Gauguin had been drawn to north-western France for financial reasons, the area's picturesque scenery and enduring folk customs captured his interest. He approached the unfamiliar locale determined, he said, to absorb "the character of the people and the country," believing this to be "essential to painting good pictures." In small, rapid sketches, he recorded elements of the region's animals, inhabitants, and landscape (see fig. 5). Occasionally, these studies served as the starting point for larger, more elaborate studies of the local population, especially of the women wearing their distinctive costumes, like a sheet he dedicated to Charles Laval, a young painter he met during his stay (pl. 4).

Gauguin's emphasis on the role of drawing reflected the practice of his former teacher Pissarro, who advised young artists in search of their personal style to draw continuously after nature and after primitive art, by which he meant the sculpture of the Egyptians and the paintings of early Northern European and Italian masters. "You must know drawing inside and out," Pissarro maintained, ". . . [and] remember that the primitives are our masters, for they are naïve

and wise." Gauguin had not shown himself particularly open to this approach during his Impressionist apprenticeship. Now, in the wake of the personal and professional events of the past year, he was under considerable pressure to make progress quickly, and Pissarro's words resonated. Gauguin's drawings of Breton peasants—he purposely and boldly depicted them in willfully awkward postures—reject the conventional prettiness presented by contemporary Salon painters (see fig. 6) in favor of Pissarro's aesthetic and example (see fig. 7). While the perceived "primitive" aspects of Brittany allowed Gauguin to explore figural types and subjects opposed to the urban themes of Seurat and his followers, his priority was to create decorative arrangements of color and line.

Gauguin returned to Paris in the fall of 1886, bringing with him drawings of and ideas about Brittany, which—after spending nearly a month in the hospital suffering from tonsilitis—he mined for new work. For example he reused an image he had made of a seated Breton woman (pl. 4) in a watercolor-and-gouache fan design (1886–87; private collection) and in the embellishment of one of Chaplet's vases (fig. 8). Translating his drawings into ceramic decorations, Gauguin demarcated zones of color with incised and painted outlines so that the glazes would not run during the firing process—a reductive approach

5. *Studies of Sheep*, 1886. From a sketchbook, c. 1884–88. Pen and brown ink and graphite on wove paper; 16.9 x 22.5 cm. National Gallery of Art, Washington, D. C., The Armand Hammer Collection.

6. Pascal Dagnan-Bouveret (French; 1852–1929). *Woman from Brittany*, 1886. Oil on canvas; 38.5 x 28.5 cm. The Art Institute of Chicago, Potter Palmer Collection, 1922.445.

"Their Grecian beauty," Gauguin commented about the Arlésiennes, "and their shawls with pleats like you see in the early primitives remind one of Greek processional friezes."

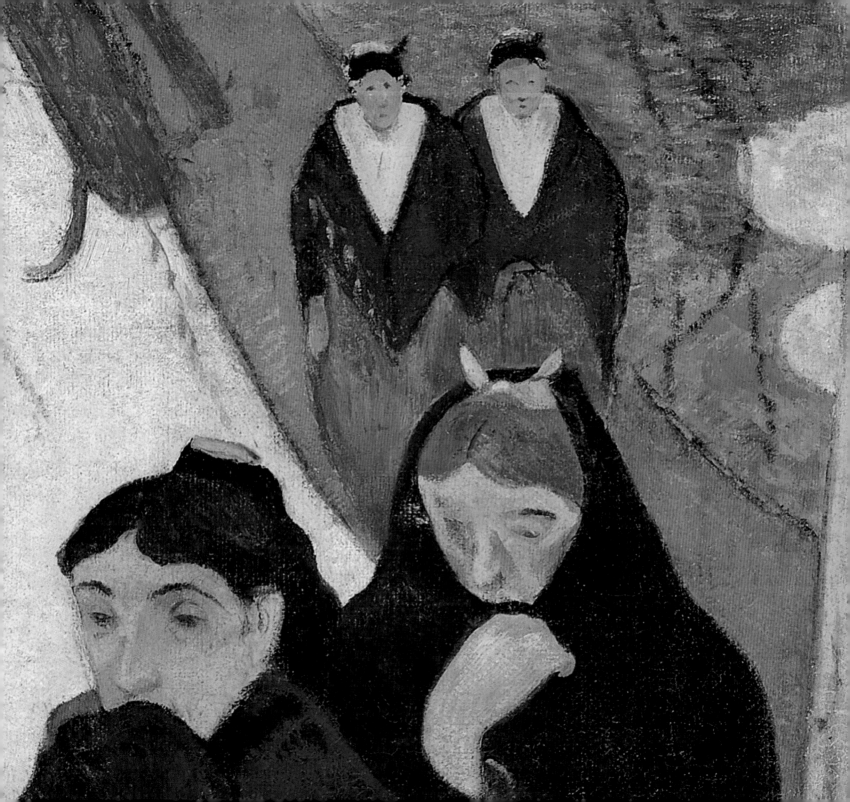

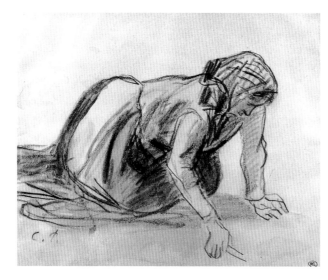

7. Camille Pissarro
(French; 1830–1903).
*Study of a Female
Peasant Weeding,* early
1880s. Black chalk with
watercolor on paper;
17.2 x 21.1 cm. Musée du
Louvre, Paris.

8. *Vase Decorated
with Breton Scenes,*
1886–87. Glazed
stoneware, with
incised decoration
and gold highlights;
h. 29.5 cm. Musées
Royaux d'Art et
d'Histoire, Brussels.

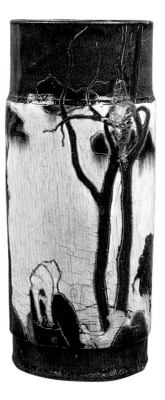

that he began to employ in his work in other media. In effect, designing for Chaplet forced Gauguin to practice the simplification that Pissarro had suggested might be learned from the "primitives."

At this time, Gauguin also made a number of unconventionally shaped pots and vessels inspired by ceramic folk-art examples, including the fifteenth- and sixteenth-century Italian majolica he admired in the Musée du Louvre, Paris, and the few Peruvian pots he knew from Arosa's collection. In this vein, he created a new, rustic base for *The Faun* that plays against the sculptural tradition embodied by the figure itself. Cylindrical in shape, with four semicircles removed to create legs, it is a decorative, formal addition rather than a naturalistic extension of the mound on which the faun sits. It also contributes to the piece's iconography, for on it Gauguin incised a flock of sheep, based on his Brittany sketchbook drawings (see fig. 5), which are here even more schematic due to the additional resistance of clay. With this new base, the faun acquired a more concrete context as herdsman, paralleling the sense of artistic leadership that Gauguin had gained as a result of his first experience in Brittany.

Despite Gauguin's hopes, ceramics did not generate the windfall he anticipated, forcing him

to remain alert to new schemes. France's economic and political situation was highly unstable; rumors of impending war with Germany and of fortunes to be had abroad made the possibility of emigration attractive. Gauguin wrote to Mette about opportunities in Madagascar and then in Central America, where his sister's husband worked. In March he and his new friend Laval decided to "flee Paris"; they set sail in April and by May were working in the city of Colón in jobs related to the building of the Panama Canal. Far from being the utopia they had anticipated, however, Panama was ugly and insalubrious, with high mortality rates resulting from rampant tropical diseases. Moreover, the Panama Canal Construction Company was corrupt, inefficient, and under investigation by the French government. In June the two artists left for the island of Martinique, a French colony since the mid-seventeenth century, where they planned "to live like savages" in a cabin outside of the island's largest city, St.-Pierre. Even though Laval contracted yellow fever, and Gauguin suffered a serious bout of dysentery and malaria, Gauguin described Martinique as "a Paradise" and, to the extent he was able, persisted with his art. He informed his friend and fellow artist Émile Schuffenecker back in Paris: "Currently, I am making sketch upon sketch [of the Martinique

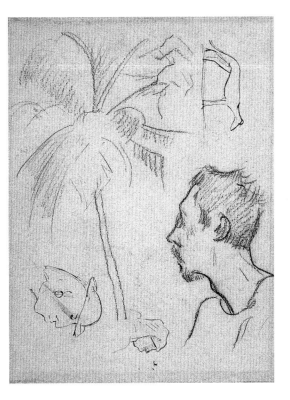

9. *Portrait of Charles Laval and Other Sketches,* 1887. Black crayon and pen with brown ink, on light gray wove paper with blue fibers altered to gray; 26.8 x 20.4 cm. The Art Institute of Chicago, Regenstein Collection, 1991.223 (recto).

islanders] in order to penetrate their character; later, I'll have them pose." Gauguin's surviving sketches record the local population, the native vegetation, and, in one case (fig. 9), an emaciated Laval looking curiously about him at his new surroundings. Larger, more finished drawings depict the island women in typical dress and characteristic postures. As with the earlier Brittany drawings, some of these studies found their way into paintings, which Gauguin considered superior to those done in Pont-Aven, since they were more "bright and clear" (see fig. 10).

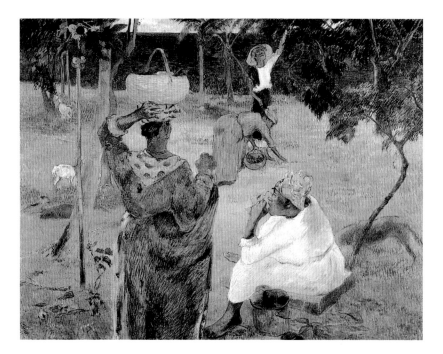

10. *Les Négresses (Among the Mangos [Martinique])*,1887. Oil on canvas; 89 x 116 cm. Van Gogh Museum, Amsterdam (Vincent van Gogh Foundation).

Due to financial and health problems, Gauguin curtailed his stay in Martinique; he was back in Paris by mid-November 1887. Yet the voyage seems to have had a decisive impact on his view of himself and his artistic mission, for it was shortly after his return from this experiment in "living like savages" that he first articulated the persona around which he would develop his career. "You must remember," he wrote to his wife, who wanted him to rejoin the family in Denmark, "that I have a dual nature, [that of] the Indian and [that of] the sensitive civilized man. The latter has disappeared [since my departure], which permits the former to take the lead." Gauguin insisted on the fundamental dualism of his character, claiming his mother's Peruvian ancestry to define himself as both European and foreign, civilized and primitive, and to create for himself a space in which to assert an unchallenged originality.

We can examine this evolution stylistically by beginning with *Breton Bather* (pl. 5), a drawing that Gauguin executed in Brittany before leaving for Martinique. He apparently began by rendering the figure in pastel during the summer of 1886; he set the sheet aside until March 1887, when he added the black contour lines, worked up the color in pastel, and squared it for transfer to canvas. At this time, or perhaps in 1888, Gauguin cropped the sheet irregularly and mounted it onto a secondary support. Thus transformed, it became a finished work on its own terms, recalling fragments of wall paintings. As the squaring and the evidence of wear around the edges testify, it also served as a working drawing. Gauguin probably began the painting to which it relates (fig. 11) in Paris, shortly before departing for Martinique. Upon returning he seems to have taken up the canvas again, redoing the foliage in tropical colors.

At this juncture, Gauguin became acquainted in Paris with the van Gogh brothers—Theo, manager of the prominent contemporary art gallery Boussod et Valadon; and Vincent, an aspiring artist then in the process of absorbing Parisian influences. This meeting proved deci-

sive. Both Vincent and Theo were deeply impressed by Gauguin's Martinique paintings, in which they saw a profound poetry that they felt Impressionism lacked. Theo purchased *Les Négresses (Among the Mangos [Martinique])* (fig. 10), and Vincent obtained another island canvas by exchanging two of his recent studies of sunflowers for it. Gauguin, for his part, was delighted at last to form an alliance with a dealer, and he was stimulated by contact with emerging artists—Émile Bernard, Henri de Toulouse-Lautrec, van Gogh, and others—who sought to move beyond Impressionism and its reliance on optical sensation. In their discussions about the future of modern art, Gauguin and van Gogh found that they shared the conviction that the urban scene was decadent, detrimental to creativity, and that artistic renewal could only be fostered in remote, unspoiled sites.

His confidence bolstered by these encounters, Gauguin returned to Brittany in the summer of 1888. Now he was more attentive to the "primitive" aspects of the land and its people than he had been two years earlier; determined to achieve what he described as a "dull, matte, powerful tone," he strove for greater stylistic rigor. He employed schematized and increasingly decorative shading and simplified facial features, and rejected conventions of perspectival depth in what he described as an innovative

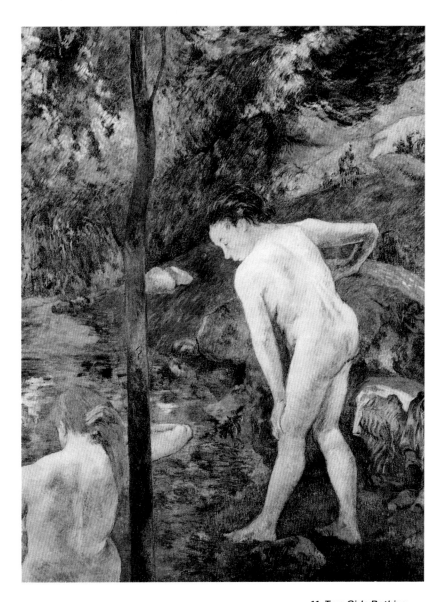

11. *Two Girls Bathing*, 1887. Oil on canvas; 87.5 x 70 cm. Museo Nacional de Bellas Artes, Buenos Aires.

synthesis of primitive and modern references. Gauguin explained to Schuffenecker, "You are a *Parisianist*. The country is for me. I love Brittany, I find a certain wildness and primitiveness here. When my clogs echo on this granite soil, I hear

As Gauguin became more attuned to the relationship between people and land, he could pay more attention to the formal beauty of his surroundings.

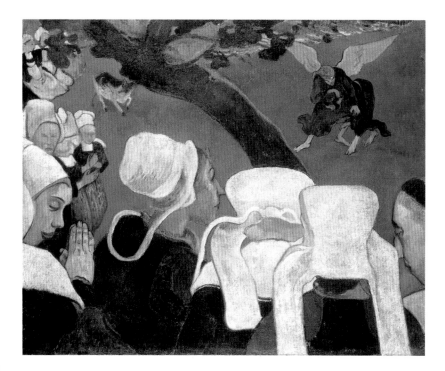

12. *Vision of the Sermon*,1888. Oil on canvas; 73 x 92 cm. The National Galleries of Scotland, Edinburgh.

departure from Impressionism, as does the ambiguous religious theme. By portraying these "superstitious" people, the artist felt that he had finally found the means to express the "symbolism that is fundamental to my nature."

Gauguin described and sketched this painting in a letter to van Gogh, who had made his own artistic journey, to Arles, in the south of France. Van Gogh dreamed of a Studio of the South, where like-minded painters—"pioneers" of a new art—could work together, and he identified Gauguin as a potential collaborator. Theo van Gogh offered to fund Gauguin's travel and living expenses in exchange for paintings, and eventually an agreement was reached. In the weeks leading up to Gauguin's arrival in Arles, he and Vincent maintained an active correspondence discussing religious painting, the contemporary art market, and materials and techniques.

In addition to this exchange of ideas, van Gogh proposed an exchange of self-portraits. Gauguin's response was the remarkable *Self-Portrait Dedicated to Vincent van Gogh (Les Misérables)* (fig. 13), a statement of his current aesthetic priorities so confident that it seems to declare the triumph of the vanguard artist over the tentative bourgeois of only three years earlier (fig. 3). Gauguin described his painting to van Gogh in a way that emphatically interweaves issues of pictorial and personal identity:

the dull, muted, powerful tone I seek in my painting." Gauguin had hit upon a strategy that served him to the end of his career: to claim the insider's sophistication, art-world knowledge, and awareness of urban moral decay, as well as the outsider's intuition of truths uncorrupted by Western civilization and the appropriate means of nurturing his essential nature. His breakthrough painting of this period is *Vision of the Sermon* (fig. 12), which shows a group of Breton women and a priest against a brilliant field of red; their collective imagination seemingly has called forth the wrestling figures of Jacob and the angel at the upper right. The vibrant, unmodulated colors and spatial distortion mark a decisive

It is the face of an outlaw, ill-clad and powerful, like Jean Valjean [a major character in Victor Hugo's 1862 novel, *Les Misérables*]—with an inner nobility and gentleness. The face is flushed, the eyes accented by the surrounding colors of a furnace-fire. This is to represent the volcanic flames that animate the soul of the artist. The line of the eyes and nose, reminiscent of the flowers in a Persian carpet, epitomize the idea of an abstract symbolic style. The girlish background, with its childlike flowers, is there to attest to our artistic purity. As for this Jean Valjean, whom society has oppressed, cast out—for his love and vigor—is he not equally a symbol of the contemporary Impressionist painter?

Here, Gauguin used "Impressionist" to characterize the avant-garde artist; he had yet to put a name to his new style, but its distance from the Impressionism of the 1860s and 1870s, as well as from the products of official academies, was evident. To realize this depiction of himself as an outsider, he adopted the persona of the protagonist of Hugo's novel, who is imprisoned for nineteen years for stealing a loaf of bread. At the same time, Gauguin created a visual vocabulary of pure color and decorative abstraction by drawing from sources beyond the Western European high-art canon.

When Gauguin joined van Gogh in Arles on October 23, 1888, the two artists embarked on an

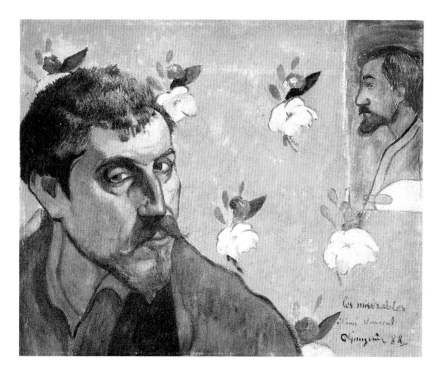

13. *Self-Portrait Dedicated to Vincent van Gogh (Les Misérables)*, 1888. Oil on canvas; 45 x 55 cm. Van Gogh Museum, Amsterdam (Vincent van Gogh Foundation).

intense period of intellectual and artistic exchange. Accepting the assigned role of leader or mentor, Gauguin attempted to guide his younger colleague to the "symbolic path," exhorting him to "paint from the imagination"—from memory—and to work in a more deliberate, controlled manner. He gave Schuffenecker the same advice: "Don't copy too much after nature. Art is an abstraction: extract from nature while dreaming before it and concentrate more on creating than on the final result." On days when bad weather kept them indoors, van Gogh experimented with Gauguin's method, conceding in a letter to his brother that images he

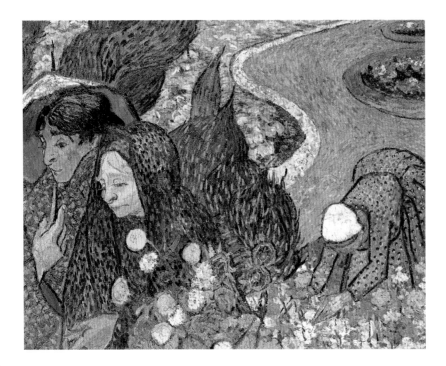

14. Vincent van Gogh
(Dutch; 1853–1890).
*A Memory of the
Garden (Etten and
Nuenen)* ,1888.
Oil on canvas; 73.5 x
92.5 cm. The State
Hermitage Museum,
St. Petersburg.

produced in this way, like *A Memory of the Garden (Etten and Nuenen)* (fig. 14), had a "mysterious character"; but the effort went against the grain.

The differences between the two men had been evident from the start, when Gauguin observed, "[Van Gogh] is a romantic, while I am more of a primitive." In contrast to the relative naturalism resulting from the Dutch artist's preference for painting directly before the motif, Gauguin's handling of space and form in *Arlésiennes (Mistral)* (pl. 6), which exemplifies his distinctive approach, appears willfully arbitrary, although he based it on numerous drawings (see fig. 15) and applied the paint with care onto a coarse, jute canvas. The image renders his vision

of Arles, where he was initially struck—as he had been in Brittany—by the picturesqueness of the local women. Of them he wrote, "Here is a source for a fine, *modern style*." By this time, the "Arlésienne" was something of a literary and pictorial cliché, a stock-in-trade figure of natural beauty wrapped in an exotic costume that evoked a distant past. As Gauguin put it, "Their Grecian beauty, and their shawls with pleats like you see in the early primitives remind one of Greek processional friezes." The setting of *Arlésiennes (Mistral)* is the Poet's Garden, the park in Place Lamartine opposite van Gogh's Yellow House, which could be seen from the downstairs studio and from Gauguin's upstairs bedroom. Walking two by two, nearly identically dressed, and flanked by the insistent verticals of the paired, conical trees wrapped in straw against the frost, the Arlésiennes seem to be engaged in a formal march, like participants in some ancient rite. The first two figures clasp their shawls to their mouths; Gauguin's title confirms that they are simply protecting themselves against the cold, northerly wind known as the mistral, but the gesture, coupled with the figures' absorbed expressions, also contributes to an atmosphere of mystery. Gauguin established a sense of compression with a steeply rising perspective: there is no glimpse of sky; the pathway seems to be blocked by the large bush and red gate in the

foreground; and the background seems to tilt up to the picture surface, flattening out the illusionary three-dimensional space.

Although Gauguin had initially intended to stay in the south of France for a year, he began to talk of returning to Martinique after only a month. Van Gogh became increasingly anxious; tensions built, and their discussions became—as van Gogh later recalled—ever more "electric." Just before Christmas, the situation exploded. Van Gogh mutilated himself after—Gauguin would claim—attempting to attack him. Gauguin abruptly returned to Paris.

Despite its unhappy denouement, the dialogue initiated with van Gogh in Arles now helped Gauguin map his course. One of his first priorities was finding a bigger audience for his recent paintings. Theo van Gogh had displayed some of his work in his gallery in the last year, but Gauguin had not participated in a major exhibition since his unsuccessful appearance in the final Impressionist show, in 1886. He now felt the need—and the confidence—to present himself on his own terms, and he turned his attention to selecting coexhibitors and to finding a venue.

Paris was astir with preparations for the Exposition universelle of 1889, a world's fair celebrating the centenary of the French Revolution and conceived to express France's

15. Drawings for *Arlésiennes (Mistral)* (detail), in Gauguin's Brittany and Arles Sketchbook, 1888–1901, page 51. Graphite and charcoal on lined ledger paper; 16.1 x 10.8 cm. Israel Museum Collection, Jerusalem, gift of Sam Salz, New York, to America-Israel Cultural Foundation, 1972.

recovery after the Franco-Prussian War. The event was designed to testify to the consolidation and achievements of the Third Republic and to resonate with a unifying spirit of nationalism. The fair would draw millions of visitors to its industrial demonstrations, cultural and scientific displays, and art exhibitions. Knowing that he would be excluded from the official art installations, which were selected by a jury of academicians, Gauguin hit upon the idea of presenting his work—together with that of Bernard, Laval, Schuffenecker, and a handful of others—in one of the cafés on the exhibition grounds.

M. Volpini, proprietor of the Café des Arts, agreed to their proposal, and from May to July the art of the "Impressionist and Synthetist Group" was on display, literally under the roof of the Fine-Arts Building. Disparate in style and quality, the works by Gauguin and his friends nonetheless shared a certain defiant anti-naturalism in terms of color and composition that distinguished them from the original Impress-ionists and the Neo-Impressionists, as well as from the representatives of official art.

An ideological declaration of independence, the Volpini exhibition was also motivated by practical considerations. In addition to paintings, which were unlikely to find buyers, Gauguin and Bernard decided to offer original prints: print-making, which was gaining prominence in the art world, allowed artists to disseminate their work more widely. Encouraged by Theo van Gogh, Gauguin produced a series of ten prints that functioned as a kind of retrospective of his recent Martinique, Brittany, and Arles themes. He signaled his break from tradition by choosing to employ the technique of zincography, a form of lithography in which zinc plates are substituted for the lithographic stone. Associated with commercial rather than fine-art printing, zinc plates yield a coarser graphic effect than the more finely textured (and more costly) Bavarian limestone typically used in lithography. And

rather than any of the white papers customarily used in the printing of artist's lithographs, Gauguin instead chose large sheets of brilliant yellow paper, similar to that employed at the time almost exclusively for certain types of commercial posters. His decision to work for the first time in lithography seems initially to have been merely expedient, but the results are highly sophisticated in terms of both technique and composition. Responsive to the unfamiliar materials and heedless of their conventional limitations, Gauguin relished the opportunity to introduce favorite motifs into a new medium. *Arlésiennes (Mistral)* (pl. 7a) may have been one of the first in the series; it faithfully transcribes in reverse the major elements of the painting (pl. 6). *Dramas of the Sea, Brittany* (pl. 7b) is a new composition related to the artist's current decora-tive projects, which included designs for fans and furniture. In all ten prints, Gauguin played with the contrast between black ink, gray wash, and yellow ground, and brought together forms that had appeared in earlier drawings and paintings without recourse to an episodic narrative.

Although now recognized as a landmark achievement in printmaking, the Volpini Suite (as the project came to be known) attracted little attention at the time of its making. Probably, only a few people saw the prints, since they were kept in a portfolio visible only on request. The

paintings sold no better. Yet by undertaking this independent venture, Gauguin effectively distanced himself from the Impressionists and Neo-Impressionists, producing and displaying distinctive work to which a new generation of critics would respond.

While devoting energy to the marketing of his work, Gauguin continued to seek motifs that would advance his art. Paris, the world's most modern metropolis—Gustave Eiffel's magnificent tower was the centerpiece of the Exposition universelle—also offered a variety of visual spectacles from exotic places and past times. Gauguin was an avid museum-goer with wide-ranging interests that he documented in his sketchbooks. In the Louvre's painting galleries, he paid particular attention to the works by early Italian "primitives"—Botticelli, Mantegna, Solario, and Uccello—and to the decorative arts, specifically Italian faience busts, cups, and plates. In a review of the Exposition that Gauguin wrote for the vanguard journal *Le Moderniste*, he contrasted the "special genius" of these pieces with the "coy, insipid . . . junk" of the present day, produced without sensitivity to the "material and the place where that material is to be used."

Gauguin drew a crucial distinction between academic conventions and those of "primitive" and folkloric art: for him the former were arbitrary, superficial, and decadent; the latter natural, intrinsic, and enduring. In search of authenticity, he also looked beyond the limits of European culture. Visiting the Louvre's newly refurbished galleries of Egyptian and Assyrian art, the artist made sketches that reveal his fascination with the way in which ancient sculptors, in rendering human anatomy, were guided as much by formal and symbolic concerns as by a desire for verisimilitude. Indeed, the common denominator of all these works is their attentiveness to representational goals other than illusionism.

Gauguin's interest in so-called primitive art led him as well to the recently opened Trocadéro museums in Paris. This complex housed an ethnographic museum, a museum of plaster casts, as well as the new Musée Khmer, conceived to showcase sculpture and plaster casts, from Angor Wat and other Cambodian sites, gathered during the many recent official "scientific missions" to the new French protectorate. The Exposition universelle featured a series of ambitious displays of a similar kind. In a special "Colonial Exhibition," the fruits of French expansion were advertised in a number of special pavilions and exhibits that included art, artifacts, and even people who had been brought to Europe to live in facsimiles of native habitats and perform ethnic entertainments, thus providing a living spectacle of the "Other"

Gauguin drew upon books and non-Tahitian sources to invent "ancestors" for Tehamana.... The two ripe mangos symbolize the abundance of the land and the fertility and sensuality of Tahitian women.

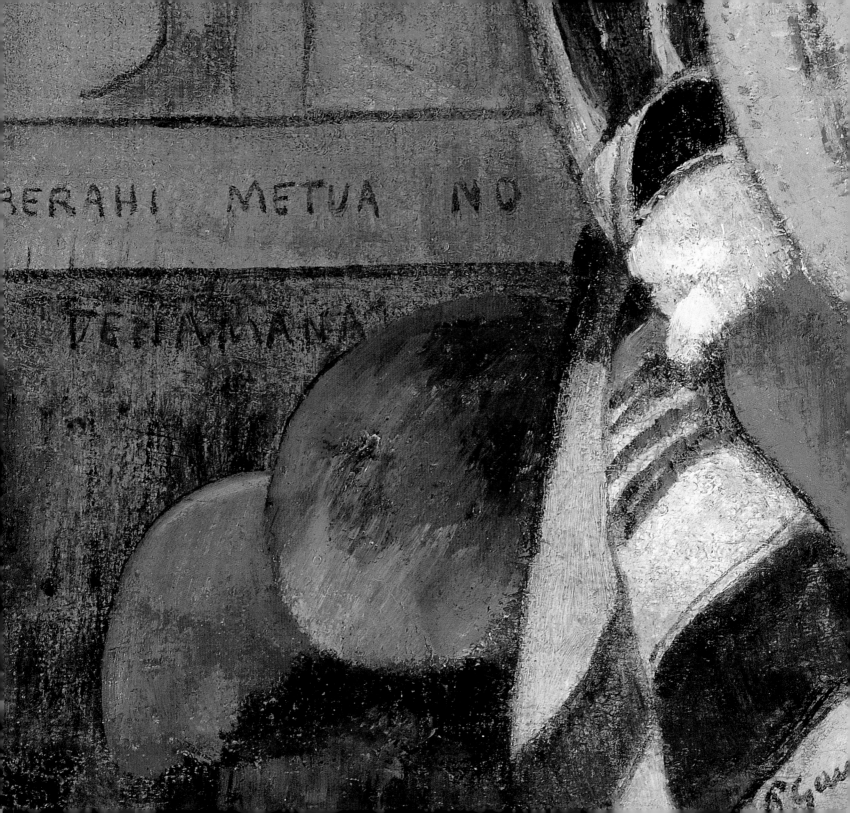

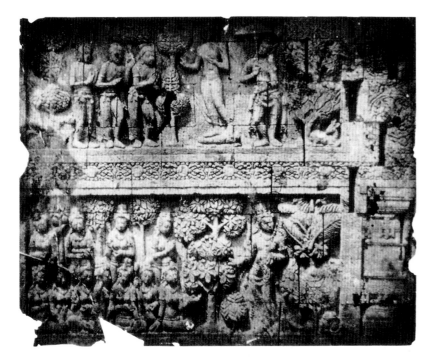

16. Isidore van
Kinsbergen (Dutch;
1821–1905). *The Tathagat
Meets an Ajiwaka
Monk on the Benares
Road* (detail). Albumen
print. From *Oudheden
van Java: De tempel
ruïne Boro-Boedoer*
(Batavia,1874), pl. 57/58.

won colonies. The vision of France's possessions presented by the government in 1889 had a powerful effect on Gauguin. It reinforced his plan, first conceived with van Gogh in the context of the Studio of the South in Arles, to create a Studio of the Tropics—a primitive utopia where art could flourish.

Gauguin's experiences in the museums of Paris and at the Exposition universelle deepened the tensions that he had already begun to represent as the essential dualism of his character, shaped by his mixed heritage. On the one hand, the contrast between the success of France's proud display of technological progress, brilliantly symbolized by the Eiffel Tower, and the dismal failure of Gauguin's exhibition staged at Volpini's café exacerbated the artist's growing alienation from dominant European notions of modernity. On the other, the displays devoted to the life and culture of "primitive" societies—from the "Colonial Exhibition" to Buffalo Bill Cody's "Wild West Show"—seemed to offer an antidote. As the brochures promoting emigration to the French colonies that were distributed on the fairgrounds attested, this fantasy lay within Gauguin's grasp.

With a vision of himself and his art focused through this lens, in June 1889 Gauguin went to Brittany for a third time. But now, apparently, he was forced to recognize that in reality Pont-Aven

for a Parisian audience. Gauguin, like many other exhibition-goers, was riveted by the performances of Javanese dancers, whose motions and gestures visually echoed the art of a pagoda that was decorated with relief molds made at Angor Wat. He remarked to a colleague, "My photographs of Cambodian [art] are rediscovered verbatim in the[se] . . . dances." In fact the photographs in question (see fig. 16), doubtless acquired from Arosa, depict reliefs from Borobudur, in the then-Dutch colony of Java, in the East Indies. This underscores both Gauguin's confused notion of imperial cartography and the success of the French campaign to create widespread public appreciation of its own recently

was no more primitive a site than were the ethnic villages in the "Colonial Exhibition." Brittany was in fact fast becoming a living museum, the face of its culture increasingly maintained and shaped by tourism. Disenchanted and intent on living "like a *peasant* by the name of *savage*," the artist left Pont-Aven for the smaller and more remote village of Le Pouldu, where he lodged at an inn run by Marie Henry. Projecting what he hoped to find there, he wrote: "The peasants seem to have stepped out of the Middle Ages and do not seem to realize for an instant that there is a Paris and that we are in 1889." His program now, as he outlined in a letter to van Gogh, was to "try to invest these desolate figures with the savage [aspect] that I see in them and which is also in me." To represent this, Gauguin occasionally incorporated into his compositions images of the old crucifixes and calvaries found in the region's churches, echoing their stylistic properties—simple shapes, rigid outlines, rustic characterizations—in paintings of his own. With a handful of followers, among them Paul Sérusier and the Dutch artist Jacob Meyer de Haan, he decorated the inn's dining room. This installation of paintings, carved panels, and stenciled borders represented an extension of self into environment that Gauguin had come to consider essential.

Gauguin prepared Theo van Gogh, his dealer of less than two years, for the decided

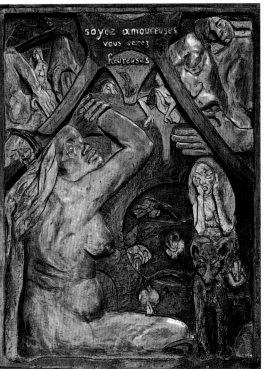

17. *Be in Love and You Will be Happy (Soyez amoureuses, vous serez heureuses)*,1889. Polychrome linden wood; 97 x 75 cm. Museum of Fine Arts, Boston, Arthur Tracy Cabot Fund.

shift in his art: "You know that by birth my background is Indian, Inca, and all that I do reflects this. It's the foundation of my personality. I am seeking to set something more natural over against corrupt civilization, with the primitive as my starting point." This conviction had motivated his recently completed wooden sculpture *Be in Love and You Will Be Happy (Soyez amoureuses, vous serez heureuses)* (fig. 17). In the piece's upper-left corner, the partial figure of a woman shielding her pubic area symbolizes the "rotten Babylon" that was Paris, with its hypocritical morals and corrupt art scene. A similar

point is seemingly made by the ambiguous juxtaposition of a nude woman, raising her arms and grasping her right wrist with her ringed left hand, and a man at the upper right toward whom she looks, his features unmistakably those of the artist, his lowered gaze and hand gesture obscure. The schematic appearance of the human and animal figures serves to critique the expectation that the "natural" resides solely in truth to the model's physical appearance.

While Gauguin provocatively embraced primitive sources and techniques, he still felt compelled to measure himself against the moderns, notably in a pair of canvases addressing the achievements of two imposing predecessors whom he greatly admired, Manet and Cézanne. One of these homages is a copy of Manet's *Olympia* (1863; Musée d'Orsay, Paris; Gauguin's 1891 version is in a private collection); the other is a more complicated and enigmatic composition, the Art Institute's *Portrait of a Woman in Front of a Still Life by Cézanne* (pl. 8). Examination of this work with the naked eye and with x-radiography reveals that Gauguin made numerous corrections and adjustments as he grappled with the mystery of the Provençal artist's technique. Undaunted by the fact that Cézanne had once accused him of plagiarism, Gauguin began by copying his favorite among the works by the artist remaining in his collec-

tion, a still life with apples, compote, glass, and knife (fig. 1). At first glance, these objects seem to exist as such behind the model, but the white frame at the left identifies them as elements in a painted composition. Gauguin adopted the "constructive stroke" that Cézanne had devised around 1880 as a way of disciplining unruly Impressionist sketchiness; this stroke appears in the model's blouse, dress, and hands as well. She is as yet unidentified, and indeed this is less a portrait of an individual sitter than it is an interpretation of Cézanne's roughly contemporary portraits of his wife, which similarly present a monumental and psychologically opaque female figure. Ultimately, the interest of Gauguin's canvas lies not in its resemblance to prototypes by Cézanne but in its exploration of painting as artifice, always based as much on art as it is on life. Gauguin was determined to experience both on equal terms.

For his most recent innovations in Brittany, Gauguin sought to evoke a sense of mystery by relying upon his observations of the region and increasingly on the more exotic visual forms found in the art of distant cultures. To this end, he felt the need for a more authentically rejuvenating experience in a faraway land. "The savage," he informed van Gogh, "will return to the savage state." Gauguin's plans for physical and spiritual escape from the strictures of

European culture were shaped by the version of colonialist ideology that he had absorbed in Paris. When he imagined at last realizing the ambition of a Studio of the Tropics, he envisioned a "native hut like those . . . seen at the Exposition universelle." Because all of the destinations he considered over the next months—first Tonkin (now North Vietnam), then Madagascar, and finally Tahiti—were territories claimed by France, he expected some form of official sponsorship for his project. His dream and strategy—to emerge as "the Saint John the Baptist of the painting of the future, strengthened there by a more natural, more primitive, less rotten [way of] life"—resonated with the promotion of colonialism as a means of revitalizing the nation's spirit and economy. Gauguin saw himself as a pioneer, heading out to make his fortune abroad. In fact he described his art as a "seed" that he hoped he could "cultivate . . . in a primitive and savage state"; like many fruits of colonial labor, his work would be exported back to France.

Gauguin's idealization of Tahiti drew upon earlier legends of the island as an earthly paradise where all needs could be effortlessly fulfilled and on current colonialist depictions of faraway French possessions as untapped resources. Refining his personal and professional image, he grew his hair long, like Buffalo Bill's, and practiced with bow and arrow on the beaches of Le Pouldu as if to ready himself for the journey that a painter friend characterized as a return to "the childhood of civilizations, . . . to the unknown, to dreams and illusions." He wished, as he stated in an interview published in *L'Echo de Paris* in 1891, to "be rid of the influence of civilization . . . [and] to immerse myself in virgin nature, see no one but savages, live their life, with no other thought in mind but to render, the way a child would, the concepts formed in my brain and to do this with the aid of nothing but the primitive means of art."

This interview was part of a spirited public-relations campaign that Gauguin launched in Paris in early 1891. Through his friend Charles Morice, he cultivated relationships with the circle of Symbolist writers who gathered around poet Stéphane Mallarmé. Sufficiently impressed, Mallarmé encouraged another associate, Octave Mirbeau, to publish favorable reviews of Gauguin's art, which was going to be sold at auction on February 23; Bernard convinced critic Albert Aurier to do the same. Their laudatory words contributed to the developing mythology of Gauguin as an unappreciated genius, a persona actively fostered by the artist. He thanked Mallarmé for his support with an etched portrait (fig. 18), his only work in this graphic medium and one laden with a deliberate symbolism

Although the arrangement of the three figures seems symbolic— perhaps of birth, life, and death— this is by no means clear.

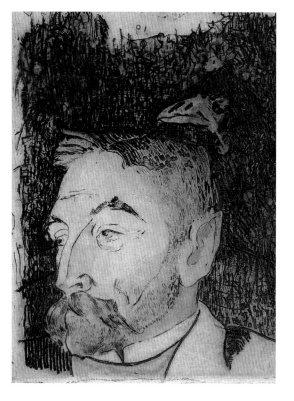

18. *Portrait of Stéphane Mallarmé* (detail), 1891. Etching, drypoint, and engraving in brown ink on cream Japanese paper; image 18.3 x 14.5 cm; sheet 33 x 24 cm. The Art Institute of Chicago, The Albert H. Wolf Memorial Collection, 1935.46.

appropriate to its subject. Gauguin endowed Mallarmé with pointed ears that allude to the poet's landmark achievement, "L'Après-midi d'un faune"; the raven in the background references his 1875 French translation of Edgar Allan Poe's "The Raven," while also acknowledging Manet's well-known lithographic illustrations for the book. Gauguin thus inserted himself into the lineage of literary and pictorial Symbolism, convinced that these connections would ensure the success of the work he envisioned producing in Tahiti.

The First Tahitian Sojourn, 1891–93

In March 1891, Gauguin requested and received from the Minister of Public Education and Fine Arts a government-sponsored assignment, a "mission to go to Tahiti to study and ultimately paint this country's costumes and landscape." After paying a brief—and, as it turned out, final—visit to his wife and children in Copenhagen, the artist set sail in April from Marseilles. He carried with him a letter of introduction to colonial officials and the collection of drawings, photographs, and prints he referred to as his "small circle of comrades." He was, as we have seen, armed as well with a set of expectations shaped by colonialist fantasies of revitalization such as Pierre Loti's bestseller *The Marriage of Loti* (*Le Mariage de Loti*), 1880, a pseudoautobiographical account of the adventures of a twenty-two-year-old French naval officer who, stationed in Tahiti, briefly gains access to the "primitive" Other through an affair with a thirteen-year-old native girl.

Gauguin reached Tahiti's capital, Papeete, just at the moment that the country's last native ruler, King Pomare V, died. This event symbolized the quandary he faced on reaching his destination: he had arrived too late. Although aspects of the king's funeral revealed a potent indigenous culture, the corrupting effects of

colonization were evident everywhere. "Tahiti is becoming completely French," Gauguin complained to his wife. "Little by little, all the ancient ways of doing things will disappear. Our missionaries have already imported much hypocrisy, and they are sweeping away part of the poetry."

After an unsatisfactory three months in Papeete, Gauguin relocated to Mataiea, a small, coastal village forty miles south of the capital. He began as he always did in such circumstances. "In each locale," he later wrote, "I need a period of incubation, to learn each time the particular character of the plants, the trees—of the whole landscape" and of its native inhabitants. As in Brittany and Martinique, drawing was a critical means of "getting the engine started in a new country . . . [of getting] used to the personality of each thing and each individual." Not yet ready to construct the ambitious, Symbolist compositions he anticipated making later, Gauguin needed first to ascertain what "realism" and "symbolism" might mean in this colorful landscape and exotic culture.

Gauguin's artistic mission was thus quite self-conscious. Typical was his report, shortly after his arrival, to one friend: "I haven't yet done a *painting*—but a pile of research that will bear fruit, many documents that will serve me for a long time, I hope, in France." Several months

later, he informed another: "I am working harder and harder, but so far only on studies, or, rather, documents, which are piling up. If they are not useful to me later, they'll be so to others." Gauguin's repeated characterization of his Tahitian drawings as precious research "documents"—as a kind of visual fieldwork constituting the necessary preliminary to the later, studio-based task of creating the synthetic statement that is the "painting"—reveals the same scientific bias reflected in his application for government sponsorship. In a representative page from a now-dispersed Tahitian sketchbook (pl. 9), Gauguin's rendering of a pandanus leaf, at the top, includes its characteristic thorns. Below this abbreviated drawing, he showed the leaves in use: a woman braiding pandanus fronds sits on a woven mat quite possibly identical to the one she is creating. The vanilla plant at the lower right, with its distinctive, zigzag stem and long, podlike seed capsules (known as vanilla beans) represents one of Tahiti's commercial crops.

Eventually, such studies resulted in paintings such as *The Big Tree (Te raau rahi)* (pl. 10) and *The Hibiscus Tree (Te burao)* (pl. 11), which at first may appear to be generalized evocations but are in fact based on close observation and attention to the characteristic rather than the picturesque. In *The Big Tree* (whose Tahitian title can also be translated as "the making of big Tahitian medi-

cine"), painted in October or November 1891, a father husks a coconut, a woman—perhaps a grandmother—looks after children, and a mother performs other chores in the background. The vegetation is more than a decorative setting, for it plays a role in the domestic narrative: Gauguin must have observed how Tahitians used the nuts and leaves of the autura tree and the pods and flowers of the hotu tree for medicinal purposes.

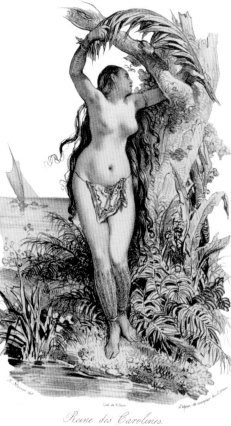

19. N. Maurin (French; 1799–1850) after J. Arago (French; 1790–1855). *Queen of the Caroline Islands (Reine des Carolines)*. Lithograph. From J. Arago, *Voyage autour du monde* (Paris, 1839), vol. 2, p. 327.

Reine des Carolines.
(Vue à Tinian.)

Here, the artist rendered these two varieties, as well as banana and breadfruit trees, with remarkable exactitude.

As Gauguin became more attuned to the relationship between people and land, he could pay more attention to the formal beauty of his surroundings. *The Hibiscus Tree*, painted perhaps a year later, in the summer or fall of 1892, is also an accurate portrayal of local vegetation, in this case a species of hibiscus. But the natural forms fostered a decorative impulse, as the artist reduced the role of figures in order to concentrate on the whiplash patterns of roots, branches, and leaves that exhibit Art Nouveau sinuousness. Gauguin wrote of another, similar image, "On the ground purple with long serpentine copper-colored leaves, there lay a whole oriental vocabulary—letters, it seemed to me, of an unknown, mysterious language."

Gauguin infused his art with mystery, often by depicting enigmatic female figures, traditional symbols of nature and its secrets. In Tahiti he expected to encounter exotic and sensual women. Given Gauguin's complicated position as both observer and participant in Tahitian society, his ambition to represent the "country's female type" bears close examination. He owned illustrated travel books in which, as he noted scornfully, "all the [natives] . . . look like Minerva or Pallas Athena" (see fig. 19). He

aimed to disrupt this conventional projection of European ideals and fantasies onto Tahitian women. In a group of striking charcoal studies (see pl. 12), he acknowledged non-classical notions of beauty. Nonetheless, his portrayal of the subject, both full face and in profile, are complicit with more modern, Western modes of representation: ethnographic illustration and photography.

His expectations conditioned by the Javanese dancers at the Exposition universelle and by the popular prose of Loti, Gauguin sought sexual relationships with local women. Soon after arriving, he became involved with an Anglo-Tahitian woman, the loquacious Titi, which he broke off because, as he would explain, "This half-white girl, glossy from contact with all these Europeans, would not fulfill the goal I had set myself." Gauguin's subsequent companion, thirteen-year-old Tehamana, whose name means "giver of strength," did, at least so his written accounts and images lead us to believe. Of Polynesian origin, less experienced, and of a seemingly "impenetrable" character, Tehamana offered Gauguin the mysterious experience he sought in life and art. His mesmerizing painting *Tehamana Has Many Parents (Merahi metua no Tehamana)* (pl. 13) is a compendium of his ideas about Tahitian culture, as well as a portrait of the young woman he claimed was his link to it. In a

drawing (pl. 12), Gauguin recorded Tehamana's features, sketching in a flower behind her left ear and delineating the prim, high collar of her "Mother Hubbard" dress, a type of garment imposed by missionaries for the sake of propriety. In the painting, Tehamana holds a plaited fan, with the flower behind her right ear. She sits before a background that, as the painting's title suggests, constitutes a portrait in its own right, alluding in three horizontal zones to the physical, spiritual, and intellectual realms. In the absence of archaeological evidence of Tahiti's past, Gauguin drew upon books, especially Jacques Antoine Moerenhout's two-volume *Travels to the Island of the Pacific Ocean (Voyages aux îles du grand océan)* (1837), and on non-Tahitian sources to invent "ancestors" for Tehamana. At the lower right, two ripe mangos symbolize the abundance of the land and perhaps also the fertility and sensuality of Tahitian women (Tehamana became pregnant with Gauguin's child at around this time). In the painting's middle range, the artist depicted figures from Polynesian mythology: most prominent is the goddess Hina, who represents the female principle that so fascinated the artist, and assumes a posture drawn from Hindu sculpture. Above, the yellow glyphs surrounding Tehamana's head derive from ancient (and never-translated) *rongo-rongo* tablets, or "talking boards," found on Easter

Island in 1864 and displayed at the 1889 Exposition universelle.

Gauguin's precious "documents" were his means of recording what he saw while pondering its deeper significance. He kept them in folders he made of stitched barkcloth (*tapa*), decorated, and variously titled "Documents Tahiti, 1891, 1892, 1893," "Soumin" (*sous-main*, or behind the scenes), and "Chez les Maoris: Sauvageries" (Gauguin used the term "Maori" broadly, to refer to all natives of the South Seas; today, it denotes the indigenous Polynesian people of New Zealand). As the pages of the sketchbooks were removed and dispersed, it is not known which of the artist's drawings each folder contained. But their function is clear: filling them gave him confidence that he had begun "to grasp the Oceanic character," and he embarked on the paintings that were his ultimate goal. A large drawing in the Art Institute collection, *Crouching Tahitian Woman* (pl. 14), provides a key to Gauguin's process of constructing his paintings from separate, isolated parts. With a grid superimposed to facilitate its freehand transfer to canvas, the pastel-and-charcoal drawing can truly be described as "preparatory"—developed specifically with the evolution of the painting *When Will You Marry? (Nafea faaipoipo)* (fig. 20) in mind. The pale-lavender *pareu* that the figure wears in the drawing is bright red in the painting;

the woman in the painting also sports a white flower behind her left ear. Her crouching posture and sidelong glance must be understood in relation to a second figure, immediately behind her, who wears a European-style dress and hairstyle, sits in an upright position, and makes a graceful gesture, looking toward her companion. The contrast between the attitudes of the two figures, together with Gauguin's interrogative title, suggests a narrative that is not fully explained, although scholars have suggested that the flower worn by the foremost figure indicates her readiness to take a husband. The ambiguity is surely intentional. In works such as this, Gauguin deliberately shrouded the exotic figures and settings in mystery, often painting Tahitian titles on the canvases in full knowledge that European viewers would not know what they meant. In so doing, he in effect pioneered a new kind of subject matter.

As seen in paintings such as *Tehamana Has Many Parents* and *When Will You Marry?*, Gauguin found that providing his figures with a vibrant cultural context was a challenging task. He now recognized that in Tahiti there remained almost nothing of the original, indigenous culture he had dreamed of inhabiting and incorporating into his art. And if the present offered nothing, even the "traces of this distant, mysterious past" were few. An actual cultural artifact that Gauguin had

the opportunity to study was a Marquesan earplug (*putaiana*). Earplugs were adornments for women, family heirlooms carved from bone. Modest in size (ranging from one to two inches in length), the *putaiana* took on literally monumental significance for Gauguin's invention of a lost Polynesian culture. At the upper right of a sheet featuring two pen-and-ink drawings of a woman, facing the artist in one image and asleep in the other (pl. 15), he made a graphite drawing of the earplug that displays the accuracy of an ethnographer. But he did not hesitate to transform the object utterly in other works. In the landscape *There Is the Temple (Parahi te marae)* (fig. 21), it becomes an architectural fence, a decorative boundary spanning the foreground of a colorful landscape that features a large idol, equally imaginary. In this way, Gauguin used his documents to create a past that had never existed. "I can guarantee that what I am doing here has not yet been done by anyone else, and that it is not known in France," he informed Mette in the summer of 1892, adding his belief that "this newness will tip the balance in my favor" back home. With these hopes of having made his fortune—and of establishing himself as a renewer of modern art—he set sail from Tahiti in July 1893.

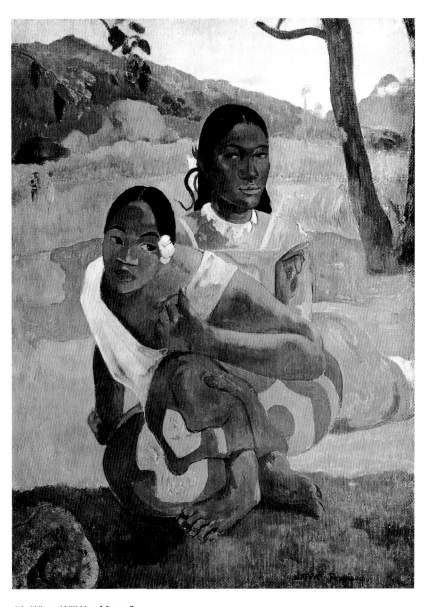

20. *When Will You Marry? (Nafea faaipoipo)*, 1892. Oil on canvas; 105 x 77.5 cm. Rudolf Staechelin Family Foundation, Basel.

Gauguin created an edenic vision by cross-pollinating sources—ancient and modern; Asian, Western, and Polynesian—fertilized by his Tahitian experience, his documents, and his previous paintings.

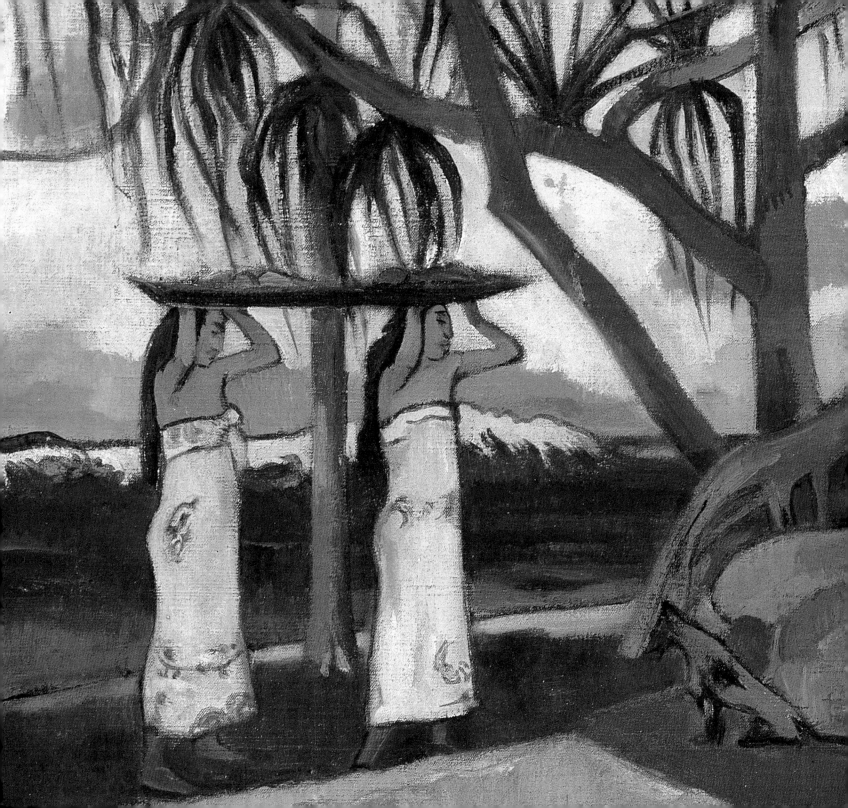

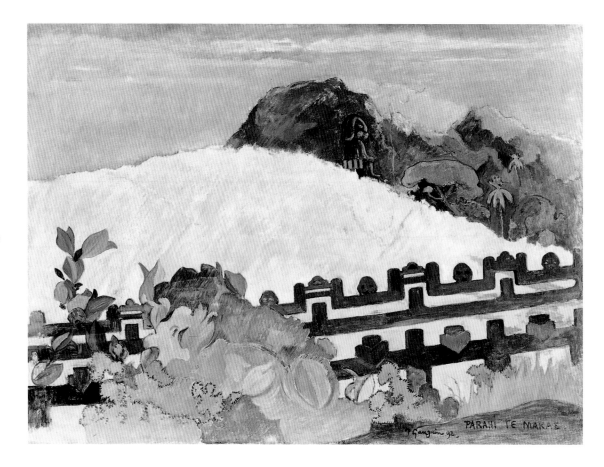

21. *There Is the Temple (Parahi te marae)*, 1892. Oil on canvas; 68 x 91 cm. Philadelphia Museum of Art, gift of Mrs. Rodolphe Meyer de Schauensee.

Return to France, 1893–95

In late August, Gauguin arrived in France penniless. But soon thereafter, his fortune changed. Through the death of his uncle Isidore, he received a modest inheritance that permitted him to mount an exhibition of his Tahitian paintings, an accounting of his "mission" to be held at the important Paris gallery of Durand-Ruel in November (artists were expected to pay for framing and publicity). Gauguin anticipated

that his Tahitian work would be recognized as novel within the Paris art world. The exhibition failed in financial terms, yet critical response to it was instructive for Gauguin. He might have expected some misunderstanding of his formal experiments, although Synthetist innovations such as patterned surfaces and unmodulated colors were becoming more familiar to Parisian audiences through the work of his younger admirers. He probably was not prepared, however, for critics' varied evaluations of the content

and aim of the work. Detractors, including the influential critic Camille Mauclair and Gauguin's old mentor Pissarro, branded the work exploitative, "colonial art"; Pissarro even suggested that Gauguin was "stealing from the savages of Oceania." But the type of bricolage that Pissarro condemned as inauthentic had long served Gauguin as a productive, creative strategy. The artist also had his advocates: the critic Roger Marx commended him as an insightful "ethnographer eminently capable of penetrating the enigma of the faces [of the Tahitians] . . . and extracting a grave beauty." Gauguin himself most appreciated the commentary of his supporter Mallarmé, who said of the Tahitian works: "It is extraordinary that there can be so much mystery in such brilliance."

Trying to put the exhibition behind him, Gauguin turned his attention to creating an appropriate context in which his art could be appreciated. In a self-conscious performance, he played up his role as "the painter of primitive natures," deliberately blurring the distinction between art and life. He rented a studio on rue Vercingétorix, painted its walls a brilliant chrome yellow, and decorated it with his unsold Tahitian paintings, their initially white frames now the same yellow as the walls. In addition he pinned up his drawings and displayed foreign artifacts, including textiles and boldly patterned *tapa*. On this stage set evoking Tahiti, Gauguin presented himself as the exotic bohemian, both in his dress and in his choice of another thirteen-year-old companion, a native of Sri Lanka nicknamed "Annah la Javanaise," and her pet monkey.

In this environment, Gauguin produced several new paintings in which he attempted to synthesize his Tahitian experience. One of the most significant of these is the Art Institute's *Day of the God (Mahana no atua)* (pl. 16). Monumental in conception, although not particularly large in size, *Day of the God* concentrates Gauguin's imagery within a formally and thematically complex composition organized on three horizontal levels. At the top, figures perform various activities in a landscape with trees, a coastline, and a large idol (not in fact Tahitian but derived, instead, like the figure of Hina in *Tehamana Has Many Parents*, from photographs of Hindu sculptures). Sitting at the god's feet, in a middle ground of pink sand, is a female bather, flanked by two ambiguously gendered figures lying on their sides, one facing front, the other back. Although the arrangement of these three figures seems symbolic—perhaps of birth, life, and death—this is by no means clear. The trajectory toward mystery continues in the canvas's lower third, which is in effect an abstract color study, a resplendent demonstration of the theories that Gauguin had been formulating since drafting

"Synthetic Notes" in Rouen in 1885. With elements fitted together like puzzle pieces, *Day of the God* is overtly decorative and stylized in a way that distinguishes it from the paintings Gauguin produced in Tahiti (see for example pls. 10–11), which are rooted in their setting and thus display a certain suppleness that this more brittle image lacks.

In his rue Vercingétorix studio, Gauguin hosted gatherings attended by painters, writers, and musicians, occasionally reciting from his manuscript of a "book on Tahiti . . . that will prove very helpful in making my painting understood." A report of his spiritual and artistic rejuvenation through contact with primitive nature and culture, Gauguin's "book," followed Loti's format in describing a foray outside the boundaries of Western civilization, an exotic adventure that, while cut short by the call of duties back home, leaves the protagonist more in touch with his primal self, and at once younger and wiser. Gauguin's title, *Noa Noa* (Tahitian for "perfume"), suggests his conception of the island as an antidote to the stench of a decadent European civilization. Gauguin shared his text with Morice, who served as collaborator, refining the artist's prose while adding some of his own poetry. Early in 1894, Gauguin began to think about how to illustrate the publication and explored several possibilities, none of them

straightforward or conventional. The text, like the artist's favored visual imagery, is vivid but elliptical and multilayered. For example he wrote about a scene he had observed in the mountains: "Suddenly, at an abrupt turn, I saw a naked young girl leaning against a projecting rock. She was caressing it with both hands, rather than using it as a support. She was drinking from a spring which in silence trickled from a great height among the rocks." This passage is pictorially descriptive, and indeed Gauguin had already painted it in Tahiti in 1893 (private collection) before producing a watercolor version, *Mysterious Water (Papa moe)* (pl. 17), in Paris. Before this, however, he had seen a photograph of such a scene, where the "spring" is actually water from a drainpipe (fig. 22), and had read Loti's account of a hike through the island's mountainous interior. Both Gauguin's words and the Art Institute's watercolor, then, are variations on a theme whose origins lie somewhere between observation and fantasy.

With its irregular borders, rich surface, and scumbled effects, resulting from the interaction of the medium with the tooth of the paper, *Mysterious Water* wholly unsuitable for current methods of mechanical reproduction. As Morice pointed out, "The colors do not come out and the grain of the paper does." But Gauguin resisted the suggestion that another artist

"translate" his imagery into a more easily duplicated form. He was already working on another project: an album of ten woodcuts (pls. 18–22), physically independent from the book, that would function as its visual complement.

Gauguin's *Noa Noa* suite is exceptional in the history of graphic art. To begin with, the choice of medium was remarkable. Popularized by German artists Albrecht Dürer and Lucas Cranach in the fifteenth and sixteenth centuries, the coarse technique of woodcut was just beginning to receive renewed attention. In his *Noa Noa* prints, Gauguin combined this technique with that of wood engraving, using tools as diverse as chisel, gouge, knife, needle, and sandpaper to produce works that—like his earlier wooden sculptures—display refinement while capitalizing on the rough, "primitive" qualities of the woodcut medium. In printing his boxwood blocks, Gauguin increased the medium's expressive range by various means: staining the paper support with color prior to printing, applying inks to the block inconsistently, and exerting uneven pressure during printing. The resulting impressions appear to move in and out of focus; the images are blurry, indeterminate, and elusive. The artist-engraver Louis Roy, under Gauguin's supervision, printed an edition of about thirty impressions that are both more consistent and legible than Gauguin's own but still preserve a

22. Charles Spitz (French; active Tahiti 1870s–80s). *Vegetation in the South Seas*, before 1889. Photograph. *Autour du Monde* (Paris, c.1889), pl. 24. From Ronald Pickvance, *Gauguin*, exh. cat. (Martigny, Switzerland, 1998), p.148.

mysterious aesthetic, as revealed by a comparison to the highly readable impressions that the artist's son Pola pulled from the existing blocks years later.

In form, content, and iconographic complexity, the *Noa Noa* series is unprecedented in Gauguin's oeuvre. Confronted with the mystery of contemporary Tahitians and that of their vanished culture, the artist felt challenged, as he described in *Noa Noa*, "to rediscover the ancient hearth, to revive the fire in the midst of all these ashes." Now, in images that recombine motifs from earlier works, Gauguin created a rich and highly inventive mythic vision that can be read as unfolding in episodic sequence. *Noa Noa*

"Suddenly, at an abrupt turn," Gauguin wrote, *"I saw a naked young girl leaning against a projecting rock. She was caressing it with both hands, rather than using it as a support. She was drinking from a spring which in silence trickled from a great height among the rocks."*

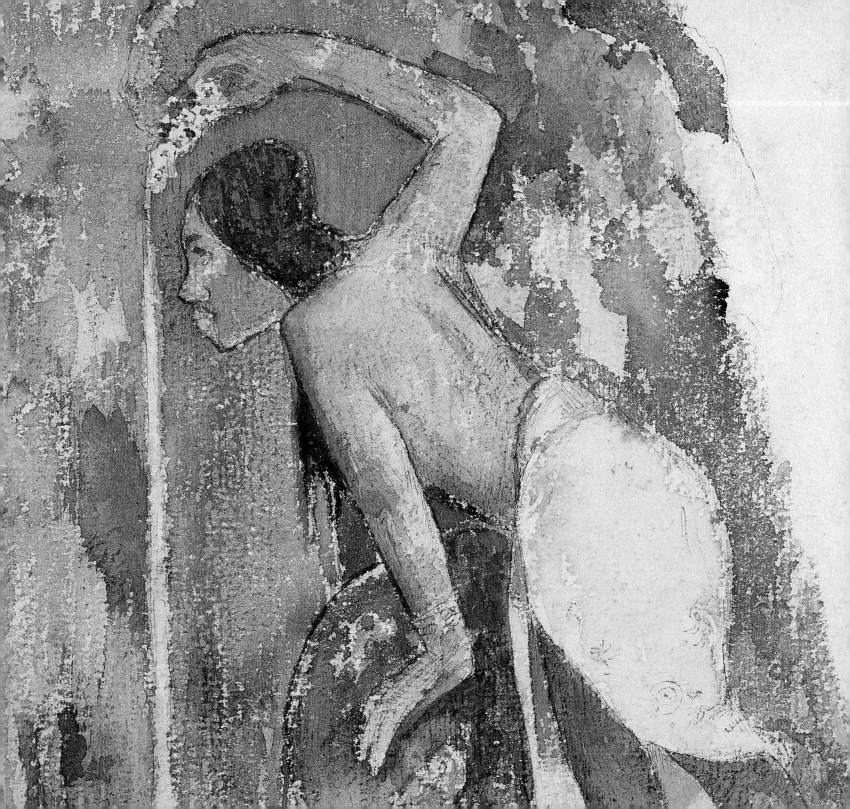

opens with a title or cover sheet representing the food-gathering that was part of contemporary Tahitian life (pl. 18a); this is followed by *Night (Te po)*, a scene in which Gauguin the narrator (his initials are carved into the moon and his self-portrait encircled by a halo) begins his tale, in the presence of an evil spirit and before a recumbent, shrouded figure, perhaps symbolic of Tahiti's sleeping past (pl. 18b). His legend starts with the deities Hina and Te Fatou, the alpha and omega of Polynesian mythology as Gauguin understood it (pl. 19a), and proceeds to the creation of the universe (pl. 19b). Following a period of contentment and grateful reverence for the gods, shown in *Offerings of Gratitude (Maruru)* (pl. 20a), evil enters the "fragrant isle" in *The Delightful Land (Nave nave fenua)* (pl. 20b) in the form of a dark lizard which tempts the Tahitian Eve. Then, in *The Devil Speaks (Mahna no varua ino)*, a fire dance seems redolent of both desire and danger (pl. 21a). In *Here We Make Love (Te faruru)* (pl. 21b), physical union brings brief transcendence, but a malevolent spirit floats above the passionate couple. Love yields to jealousy; a lone female figure turns her back on life in *Women at the River/Sea (Auti te pape)* (pl. 22a). Finally, in *The Spirit of the Dead Watches (Manao tupapau)*, a dark *tupapau* (a spirit or specter) lurks at the upper right, presiding over a

figure whose pose suggests birth, sleep, and death (pl. 22b).

While *Noa Noa* was under way, Gauguin left Paris for Pont-Aven, hoping to live more cheaply and work more productively among an appreciative circle of artist friends. However, a badly broken ankle—resulting from a scuffle between local sailors and Gauguin and his entourage—kept the artist bedridden for several weeks, a period of enforced immobility during which he could only work on small-scale drawings and relief prints. He continued to meditate on Tahitian themes, transforming them yet again with still more techniques of his own devising. Whereas the *Noa Noa* woodcuts revel in mysterious darkness and lush settings, a group of simple figure studies produced in Pont-Aven using a color transfer method are pale and soft, with minimal background detail. For images such as *Tahitian Girl in a Pink Pareu* (pl. 23), Gauguin began by creating a watercolor or pastel matrix. He then placed a dampened sheet on top of the matrix drawing and, by applying pressure to the back of this second sheet with a spoon or another implement, he caused pigment to be released from the first to the second sheet. Two or three prints of this sort could be made from a single matrix, their strength varying as a result of the amount of pressure, solubility of pigment,

and type of paper. Produced in part by chance, these transfers are characterized by a slightly blurred quality that makes them seem the representation less of present experience than of a distant memory on the verge of fading away. They appear to embody Gauguin's nostalgia for an irretrievable past (or pasts)—the ancient Tahiti he never knew, but had imagined in Brittany, where he had earlier attempted such a retrieval as well.

These continued ruminations on Tahiti, coupled with the disappointing response to his work in Paris, convinced Gauguin that Tahiti was more than an interlude in his career—it was his life's destiny. He had intended to produce enough work to make a name for himself and settle in France permanently, but realized he could not survive in the urban art world. Returning to his Paris studio in mid-November, Gauguin set his sights on going back to the tropics. Hoping to generate interest in an auction of the paintings that had not sold at Durand-Ruel's, he installed his new transfer drawings and woodcuts and invited critics and potential collectors to an "open house." He still had staunch supporters in vanguard circles and probably expected playwright August Strindberg to echo the praise of Mallarmé, Morice, and others when he asked him to provide a preface

for the sale catalogue. Strindberg surprised him by refusing, but Gauguin enhanced his outsider status by printing the rejection and his own response. Summarizing what he hoped to achieve in his Tahitian works, the artist claimed that he had sketched "another world," one unknown to scientists, inhabited by an "ancient Eve" and represented by means of "savage drawing . . . naked and primordial," like the languages of Oceania.

This is the spirit Gauguin sought to embody in the stoneware sculpture he made around this time and called *Oviri* (fig. 23), which means "wild" or "savage" in Tahitian and is also the title of a melancholy Tahitian song. In creating *Oviri*—one of his last and greatest ceramics—Gauguin enacted his desire to fuse the "primitive" and "civilized" by combining many disparate sources: Eugène Delacroix's 1836 representation of the Saône River in the Palais du Corps Législatif in Paris; the Assyrian figure of Gilgamesh in the Louvre; Marquesan mummified skulls (the eye sockets of which are encrusted with mother-of-pearl); and Hindu images of fecundity from Borobudur friezes. The iconography of Gauguin's monumental female figure crushing a wolf beneath her feet and clutching a wolf cub in her arms is by no means precise. Morice called it *Diana the Huntress (Diane chasseresse)* in 1896; in

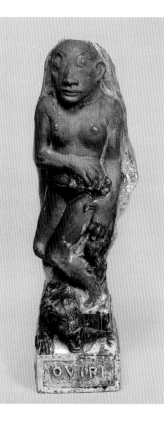

23. *Oviri*, 1894.
Stoneware, partially
glazed; 75 x 19 x 27 cm.
Musée d'Orsay, Paris.

a later letter, Gauguin called it *The Murderess (La Tueuse)*. It seems to address themes of life and death, and indeed Gauguin wished it to be placed on his grave (where a bronze replica was eventually erected in 1973). It is also an incarnation of the mystery Gauguin courted so assiduously. A woodcut variation of *Oviri* (pl. 24) is even more ambiguous than the sculpture: the figure appears androgynous, the animals are indiscernible, and the murky setting contains only a single palm tree. Its most striking aspect is its texture, which Gauguin created by applying a

mixture of oil paint, ink, and solvents to the wood block with brushes or with a rough-textured secondary material; double printing (as on the right-hand side of the Art Institute's double impression); or allowing residual ink from previous printings to remain on the block (as on the left). The paper thus takes on the appearance of the sculpture's irregular glaze: smooth and shiny in some areas, rough and matte in others. The *Oviri* print is even more powerful by being only partially articulated. This sort of indistinctness was perfectly aligned with the Symbolist aesthetic of suggestion and allusion, as Gauguin surely recognized when he wrote the dedication to Mallarmé: "this strange figure, cruel enigma."

The February auction was disappointing, although Degas purchased two paintings, and in April *Oviri* was rejected from the Salon de la nationale. Gauguin consigned *Noa Noa* to Morice, left paintings with other friends, and prepared to leave France. At the beginning of July 1895, he again set sail for Tahiti. He would never return.

The Second Tahitian Sojourn, 1895–1901

One can only imagine the complex feelings that occupied Gauguin on the long, uncomfortable passage. He was renouncing a great deal, including his wife and children, his circle of friends and supporters, the familiar conveniences

of urban life. But his "exile" was strategic, intended to sustain his creative freedom and ensure his historical position. Now he had to truly believe what he proposed in his art: that human beings could only achieve happiness or fulfillment by immersing themselves in primitive ways. Yet he had already spent two years in Tahiti, and, as he wrote in *Noa Noa*, he knew that "all its ancient grandeur, its personal and natural customs, its beliefs, and its legends had disappeared." He must have been encouraged to find, en route to Tahiti, some physical traces of the indigenous Polynesian culture that had been so elusive during his first stay there. During a stopover in Auckland, New Zealand, he studied and sketched examples from the important collections of Maori art in the newly opened wing of the Auckland Museum. Among the objects that drew his attention were tikis, the carved decorations incorporated in meeting- and storehouses, and wooden treasure boxes.

By contrast Gauguin arrived back in Tahiti to find it even more Europeanized than he had remembered. "Papeete, the capital of this Eden, Tahiti," he observed bitterly, "is now lit with electricity. A merry-go-round spoils the great lawn in front of the old king's garden." At the same time, the military repressed the attempts of natives on neighboring islands to defy colonial rule and its imposition of "civilization" with a great show of military force. Gauguin described himself as "sickened." He announced his plan to escape European contamination by moving to the Marquesas, the remote group of islands sighted in 1595 by the Spanish explorer Alvaro de Mendaña de Neira and situated some 750 miles to the northeast of Tahiti.

But six years were to pass before Gauguin left Tahiti. During that time, he was plagued by financial problems and ill health, which included a series of heart attacks. Even though these misfortunes affected the volume, quality, and methods of his production, he continued making art. Perhaps because he had largely satisfied his need to reach an understanding of his surroundings, he apparently executed few sketches and drawings like those of his first sojourn. But the documents he had produced between 1891 and 1893 proved very useful, as were the prints and photographic reproductions that remained his constant companions. Gauguin cultivated them much as he did his garden in Punaaiua, on the island's west coast: here, among Tahitian plants, he sowed seeds of European flowers sent by friends to make his own, "authentic Eden." Similarly, in his art, he now concentrated on creating an edenic vision by cross-pollinating sources—ancient and modern; Asian, Western, and Polynesian—fertilized by his Tahitian experience, his documents, and his previous paintings.

His initials carved into the moon and his self-portrait encircled by a halo, Gauguin began his tale in the presence of an evil spirit and before a recumbent, shrouded figure, perhaps symbolic of Tahiti's sleeping past.

The Art Institute's canvas *Why Are You Angry? (No te aha oe riri)* (pl. 25), a rare reworking of a painting from the first trip (fig. 24), allows us to examine the artist's changed priorities. The earlier work, very much aligned with *The Big Tree* (pl. 10) and *The Hibiscus Tree* (pl. 11), seems to record a particular site; the artist probably based it on sketches of vegetation and of people going about their daily activities. In *Why Are You Angry?*, Gauguin reduced the landscape's prominence and complexity, establishing a symmetrical composition with a palm tree in the center. The figures are larger and more numerous, their postures and characters more difficult to interpret. The interrogative title encourages us to seek some sort of narrative, but the imagery resists definitive readings. The groupings of women, which resemble clusters of hens and chicks, can be identified with different social roles. Perhaps, the figure seated at the far left asks the question of her bare-chested companion, whose downcast eyes and enervated air suggest discontent. Or the pouting woman with milk-heavy breasts may be frustrated by the obligations of motherhood and envious of the sensual freedom of the elegant woman standing to her left, who is adorned to attract men.

Large paintings such as *Why Are You Angry?* demonstrate Gauguin's desire to rival the legacy of Seurat, whose untimely death in 1891—like

van Gogh's the year before—had conferred on him a mythic status. But Gauguin also pursued other media, displaying particular sensitivity to the inherent expressive potential of each. Around 1898 he returned to woodcut, the medium he prized as "going back to the primitive times of printmaking" and considered the antithesis of "loathsome" modern photomechanical techniques. In the "little series" of fourteen woodblock prints he created at this time (see pls. 26–27), Gauguin was aware of what he called technical "imperfections," but he seems also to have acknowledged the evocative role these flaws played. Underscoring his experimental approach, Gauguin achieved the impressions by means of a particularly inventive procedure. First, he carved his designs into the woodblocks and printed them in ocher ink. He then worked the woodblocks further, refining his images while removing more of the blocks' surface. This done, he printed the blocks in black ink on very thin, transparent paper. Finally, he took these impressions and pasted them directly over the earlier, ocher impressions, thus producing uniquely rich and suggestive tonal effects.

Gauguin evidently intended some of the woodcuts in the "little series" to function together as friezes: all but two are related by virtue of their size, format, printing, and composition in ways that allow them to be considered

24. *The Big Tree*
*(Te raau rahi),*1891.
Oil on canvas;
73 x 92 cm. Cleveland
Museum of Art and an
anonymous collector.

as pairs or as groupings comprising more than two elements. This conception indicates that Gauguin was looking at his photographs of the Borobudur reliefs narrating the life of Buddha; their direct influence is seen in the predominant rectangularity of the woodcuts and in the group of three figures that enters at the left in *Change of Residence* (pl. 26). But as was increasingly his tendency, Gauguin turned for inspiration to his own work. The woodcut frieze shown here

echoes a roughly contemporaneous panel he carved for his house at Punaauia, as well as recent paintings. Earlier sources abound. The title of the right half of this frieze, *Be in Love and You Will Be Happy (Soyez amoureuses, vous serez heureuses)* (pl. 27), evokes the relief of 1889 (fig. 17) in which Gauguin had carved out his ambition to abandon a corrupt Europe for a rejuvenating, "primitive" experience. This ambition had proven more difficult than

Gauguin had imagined a decade earlier, when the objects he saw during his visits to museums inspired him to believe that an artistic "renaissance" might be possible. The ghosts of these visits—the shades of works by Delacroix, Mantegna, and Solario—are present here; disembodied, they hover over an anguished figure inspired by a Peruvian mummy, surmounted by a banderolle bearing the same message to which he had hearkened at the outset of his initial Tahitian journey.

Fisherman Kneeling beside His Dugout Canoe (pl. 28) tells us more about the artistic and personal implications of this journey. Gauguin covered the woodblock heavily with black ink or another substance and waited until it was partially dry before he printed it. By hand-coloring it afterward with watercolor or diluted gouache, he was able to produce the trembling, textured effect seen in this superb impression, which emphasizes the idiosyncrasies of the wood and retains many indications of process. Gauguin had already treated the subject in two important paintings of 1896—*The Fisherman's Family (Te vaa)* (The State Hermitage Museum, St. Petersburg) and *The Poor Fisherman* (Museu de Arte Moderna, São Paulo)—but in the print, he transformed the background and the fisherman's posture, making both more arbitrary and

abstract. The parallel diagonals of the canoe, the sloping hill, and the figure's thighs and upper arms give the image a fluid rhythm.

Despite ill health, financial distress, and loneliness, Gauguin continued to work with extraordinary inventiveness. For example a charming, decorative, but otherwise unremarkable sheet of watercolor studies of cats (fig. 25)—very much in the tradition of Delacroix's sheets of animal studies (see fig. 26)—gave rise to three entirely different works in the Art Institute's collection. The front-facing cat at the upper left appears in the watercolor *Still Life with Cat* (pl. 29), and in a closely related oil painting, now in the Ny Carlsberg Glyptothek, Copenhagen. Gauguin had executed floral still lifes throughout his career, but he was dismissive of the genre. When, in early 1900, the Parisian dealer Ambroise Vollard asked him about flower paintings, Gauguin replied, "I have done only a few, and that is because . . . I do not copy nature—today even less than formerly." While this pronouncement is something of an overstatement as regards Gauguin's actual working methods, it is also an affirmation of his aim—which had crystallized in Tahiti—to invent rather than imitate nature.

Translating observed motifs into imagined contexts, Gauguin effectively transformed them

in works such as *Untitled* (known as *Woman with a Cat* and *Crouching Tahitian Woman*) (pl. 30), which incorporates the arched feline at the lower left of the sheet of studies. The naked, sphinxlike woman who grasps the cat is presented to us, and to the audience behind her, as a kind of cult figure; the horizontal boundary above suggests a curtain that the artist raises or lowers on this "savage" Tahiti of his own devising. Gauguin invented the technique, as well as the subject, of this work. First, he applied a coating of ink to a sheet of paper; then, he placed a second sheet over it and drew with pencil or crayon on the top sheet. The pressure exerted by the drawing implement transferred the ink from the first sheet of paper onto the back of the second.

Replicating the drawn composition in reverse, this transfer, rather than the initial drawing, became the finished work of art. In *Woman with a Cat*, Gauguin enhanced the coloristic effect by turning the transfer drawing over again and applying washes of color within the original drawn lines. The side with the transfer drawing takes on a subtle tonality as a result of the color glowing through the sheet. Gauguin clearly enjoyed the transfer-drawing process, relishing its "childlike simplicity," its susceptibility to chance, and its transformation of the quality of the drawn line. Rough-looking, grainy, and a dark greenish brown, the transfer drawings assume the weathered look of survivors from another age. They resemble ancient glyphs,

25. *Studies of Cats and a Head*, c.1899. Watercolor on paper; 20.7 x 29 cm. Courtesy Galerie Schmit, Paris.

26. Eugène Delacroix (French; 1798–1863). *Studies of Tigers and Other Sketches*, 1828/29. Graphite with pen and iron gall ink and watercolor on ivory laid paper; 38 x 48.5 cm. The Art Institute of Chicago, David Adler Memorial Fund, 1971.309 (recto).

The pouting woman with milk-heavy breasts may be frustrated by the obligations of motherhood and envious of the sensual freedom of the elegant woman standing to her left, who is adorned to attract men.

te aha oe riri

carved in rock whose surface has been patinated by time and lichen, like the few extant Tahitian ruins that Gauguin had actually seen.

Domesticated in the floral still life and feral in the transfer drawing, the cat that Gauguin must have observed in his studio appears in yet another guise in *Woman with Children* (pl. 31), a canvas that is generic in format but inscrutable in content. We do not know exactly when this painting was made or whom it depicts: scholars have suggested that the boy may be Gauguin's son, born to his current Tahitian lover, Pahura, in March 1899 and named Emil after his eldest legitimate child, and that the older woman is this boy's grandmother. The composition recalls a pervasive Christian prototype: the Virgin Mary with Christ and Saint John the Baptist. The older child, although clearly a girl, plays the role of the Baptist and holds an iconographically obscure cat. With its conventional poses and undifferentiated background, this image actually appears more strange than a roughly contemporary work, *The Dream (Te rerioa)* (fig. 27), so thoroughly has Gauguin's vision of Tahiti and its inhabitants been absorbed into our imagination. Indeed, the Art Institute's picture seems to mimic the formulas of Western portraiture, especially photography, in order to point out their inability to represent the spirits, dreams, and allegories that Gauguin saw as the Tahitian "reality."

Retreat to the Marquesas, 1901–1903

In September 1901, Gauguin at last set sail for the Marquesas, a group of islands that were considerably less developed than Tahiti and still associated with tales of cannibalism, promiscuity, and polyandry. The artist settled in Atuona, on the island of Hiva Oa, where he believed that "complete solitude will revive in me, before I die, a last spark of enthusiasm." In this flight from the European presence in Tahiti, back across time as it were, to the Marquesas, Gauguin was motivated by the same naive optimism and colonialist dreams of striking it rich that had first taken him to Polynesia: he hoped to enjoy an easier way of life, to find creative rejuvenation, to "discover . . . totally new and more savage" subject matter with which to surprise and seduce a Parisian audience. He purchased land and, with the help of his neighbors, built a house that became his most ambitious decorative endeavor, in effect a total work of art. He decorated its entrance with an elaborate frieze carved in wood, possibly inspired by the artifacts from Maori meeting- and storehouses that he had seen in the Auckland Museum and anticipated by the woodcut friezes in the "little series" of 1898–99. Inside, he adorned the walls with his recent prints, as well as with Javanese sculpture and reproductions of a range

27. *The Dream*
(Te rerioa), 1897.
Oil on canvas;
95 x 130 cm. Witt
Library, Courtauld
Institute, London.

of art, including works by Pierre Puvis de Chavannes, Degas, and Hans Holbein the Younger. These "old companions" served once again as the backdrop for new experience. But now this experience was primarily imaginative. Nearly immobilized by advanced syphilis, Gauguin concentrated on writing and on small-scale works on paper. Perhaps grappling with issues of mortality, he pondered comparative religions, an area in which he had read widely. In 1902 he produced "The Modern Spirit and Catholicism" ("L'Esprit moderne et le Catholicisme"), a revision of an 1897–98 manuscript that critiques orthodoxy and explains his understanding of Christ's birth as a parable, not a historical event, with manifestations in various cultural traditions. Attempting to produce a cover design for his text, Gauguin worked on a number of transfer drawings that feature various iconographic idiosyncrasies. In *Nativity (Mother and Child Surrounded by Five Figures* (pl. 32) for example, the setting seems to be a cave rather

than a stable. The only clearly identifiable character is the child, whose halo marks him as Christ, but his downward-pointing gesture is puzzling, as are the muscular male figure, to the right of the group of women, and the skeletal figure standing in the background.

Gauguin named his "little Marquesan fortress" the House of Pleasure (Maison du Jouir). But this turned out to be something of a misnomer. The presence of a new teenaged companion, Vaeoho Marie Rose, did not defend against the fact that his health was deteriorating. He quarreled with the local French authorities. Discouraged, he wrote a friend in August 1902 that he was seriously considering leaving the islands to settle in Spain. In reply he was told that he must remain: returning to Europe would compromise the legendary status he was fast attaining. "In short," he was counseled, "you enjoy the immunity of the departed great, you have passed into the history of art." Gauguin listened and foreswore the castles in Spain.

On May 8, 1903, aged fifty-four, Gauguin died alone in his House of Pleasure. The legend of his life was secured and has been celebrated ever since. More enduring are the fictions that are his work, an oeuvre of unquestionable beauty and seminal importance to the history of modern art. Gauguin saw the values he espoused—and the creative self he wished to be—threatened with extinction by the seemingly inexorable forces of progress and the homogeneity of modern life. He attempted the impossible: to escape from the present to a cultural past in order to make an art of the future. He took refuge in art that spoke of earlier civilizations; he sought out exotic places where the past purportedly still lived. Inevitably, he was disappointed and ultimately effected his escape imaginatively, by inventing dreams of a world that never existed. Born of the "ups and downs and agitations" of his life, as he put it, Gauguin's provocative and enchanting work occupies a unique territory in our time. Although the terms "multicultural" and "postcolonial" have now become current, suggesting a certain sophisticated distance from nineteenth-century cultural structures, we still confront some of the same problems that Gauguin did when he attempted to transcend boundaries of place and time. He wrote, "I believe that the thought which has guided my work . . . is mysteriously linked with a thousand other thoughts, some my own, some those of others." Gauguin's art thus invites us to participate in a richly challenging, rewarding, and ongoing dialogue.

Plates

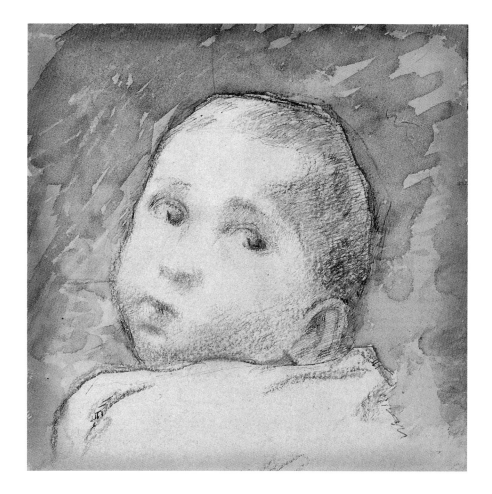

1 . Jean René Gauguin

1881

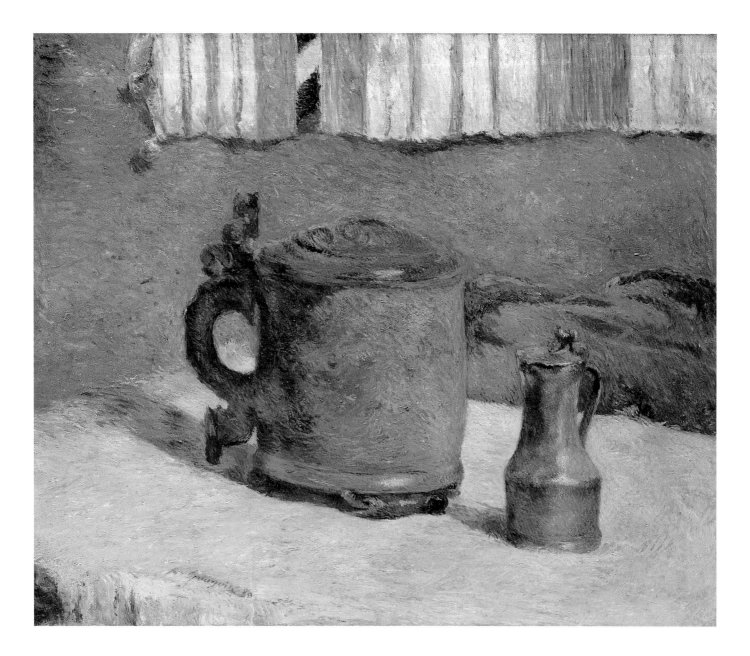

2. Wood Tankard and Metal Jug

1880

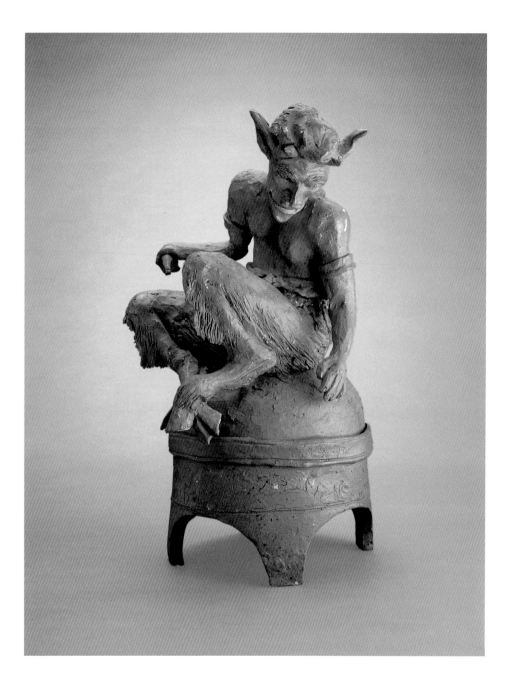

3. The Faun

1886

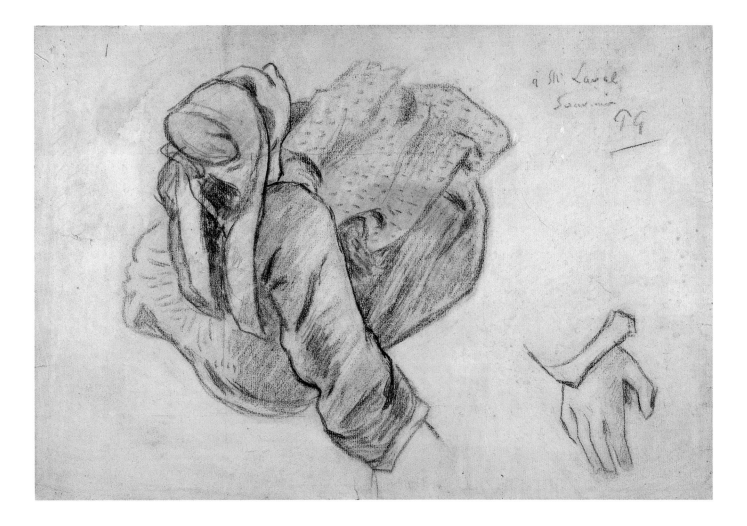

4. Seated Breton Woman

1886

5. Breton Bather

1886–87

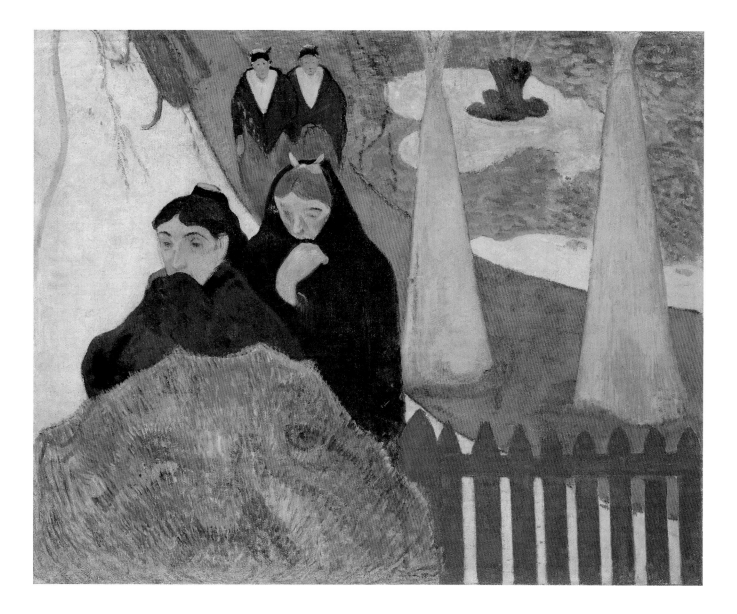

6. Arlésiennes (Mistral)

1888

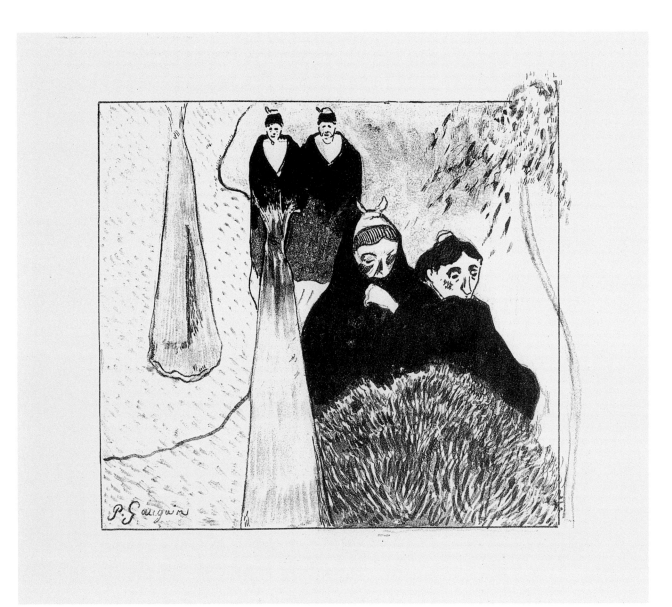

7a. Arlésiennes (Mistral), plate 9 from
Dessins lithographiques, known as the *Volpini Suite*

1889

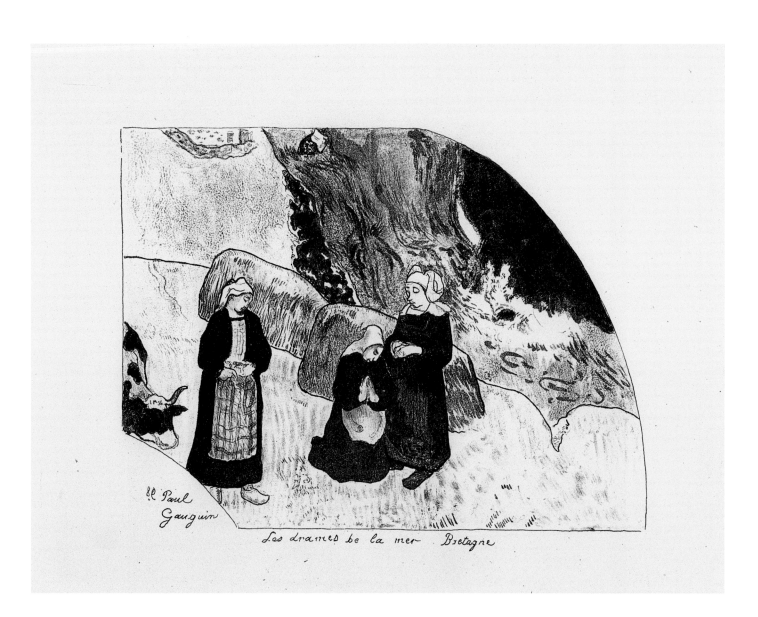

7b. Dramas of the Sea, Brittany, plate 2 from the *Volpini Suite*

1889

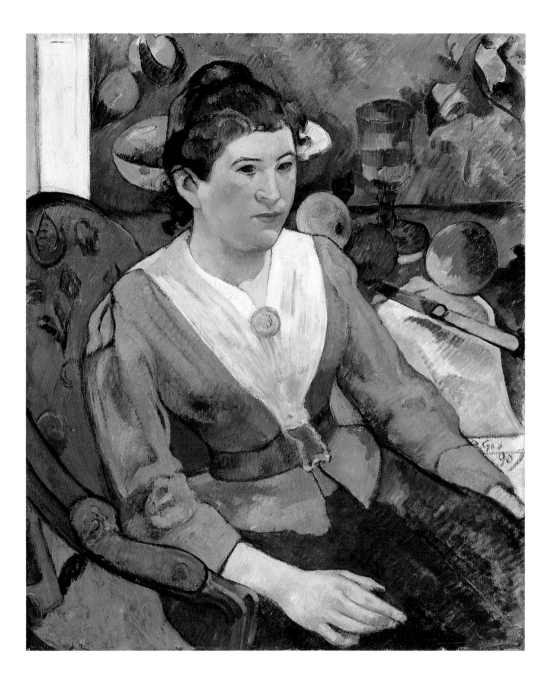

8. Portrait of a Woman in Front of a Still Life by Cézanne

1890

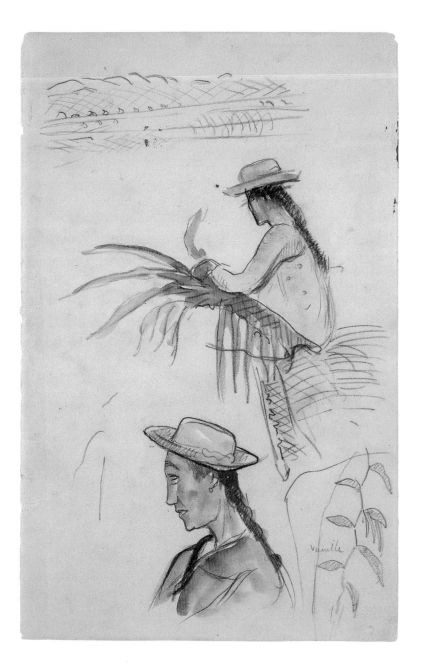

9. *Page from a Tahitian Sketchbook Featuring a Pandanus Leaf, a Seated Tahitian Woman Weaving Pandanus Leaves, the Same Figure in Profile, and a Vanilla Plant*

1891/93

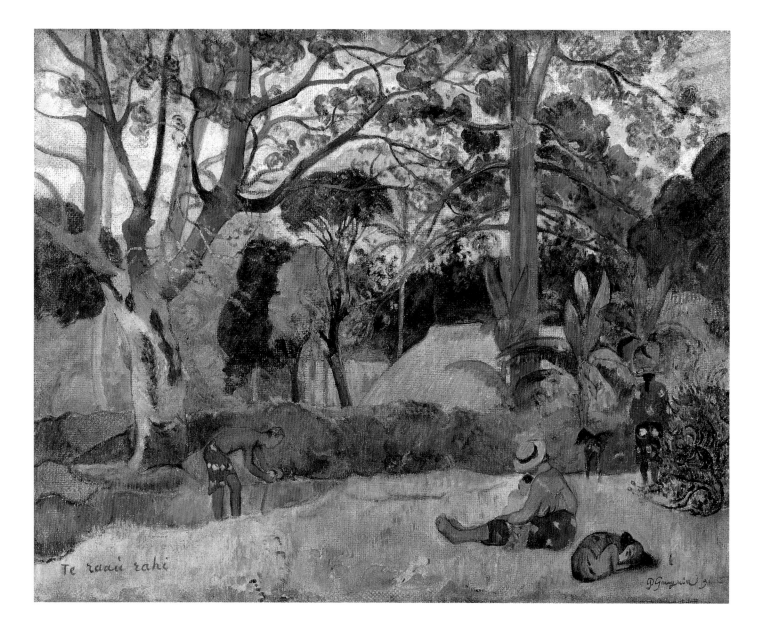

10. The Big Tree (Te raau rahi)

1891

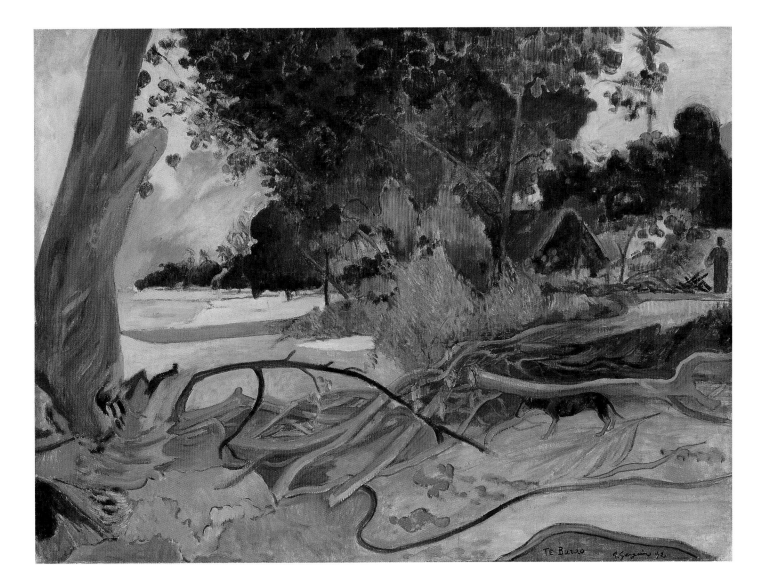

II. The Hibiscus Tree (Te burao)

1892

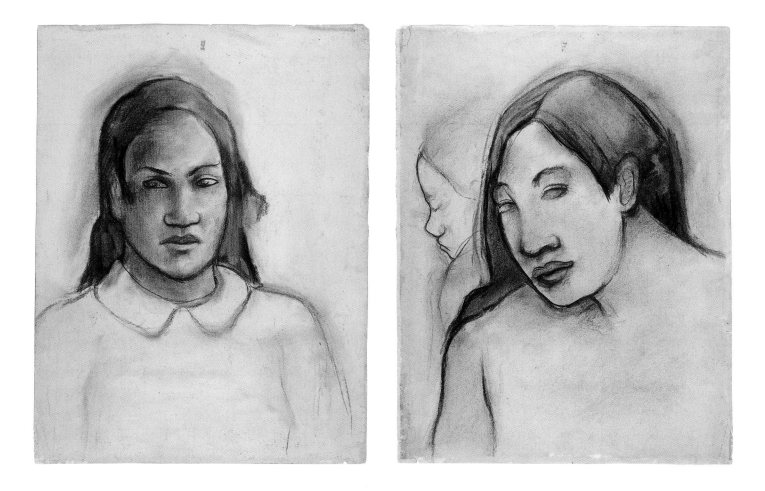

12. Heads of Tahitian Women, Frontal and Profile Views (recto and verso)

1891/93

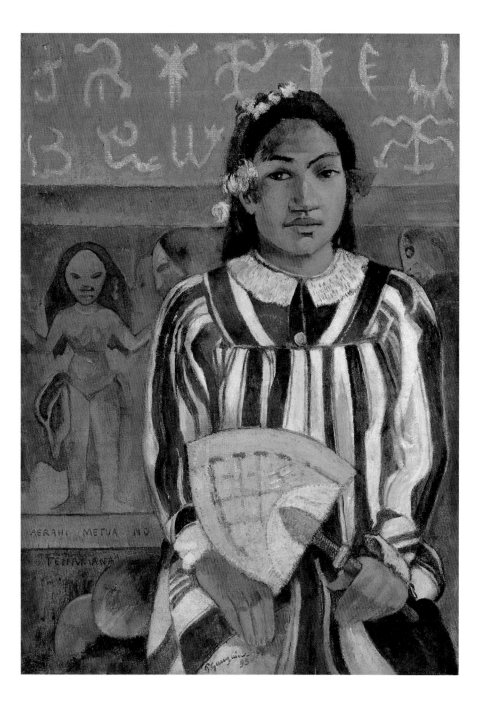

13. Tehamana Has Many Parents (Merahi metua no Tehamana)

1893

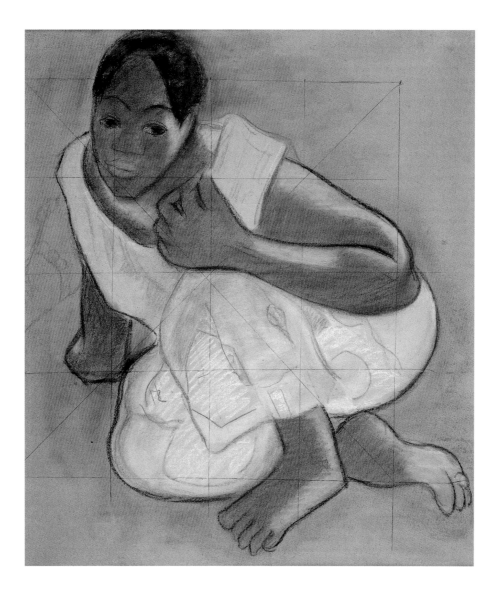

14. Crouching Tahitian Woman: Study for "When Will You Marry? (Nafea faaipoipo)"

1892

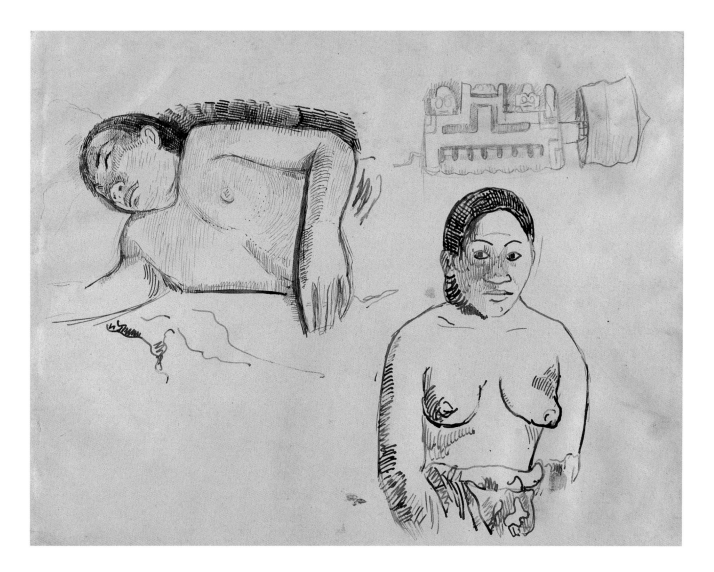

15. Two Sketches of a Tahitian Woman and a Marquesan Earplug

1891/93

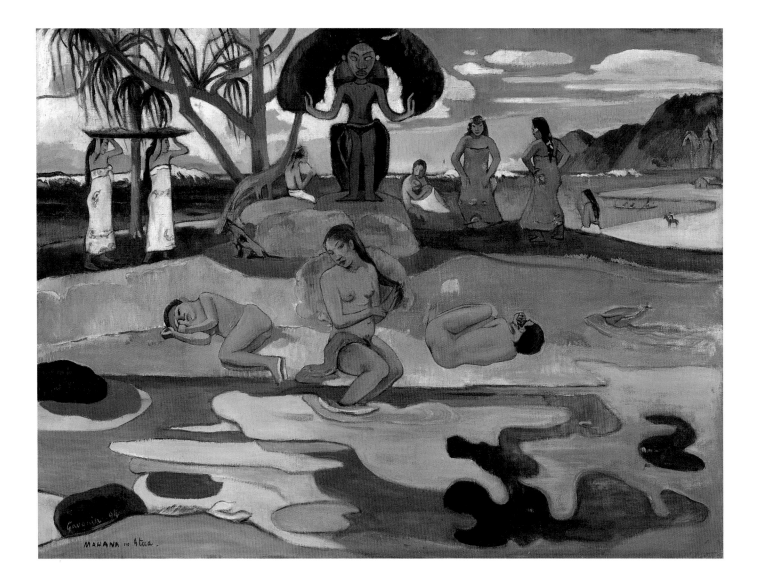

16. Day of the God (Mahana no atua)

1894

17. Mysterious Water (Papa moe)

1893/94

18a. Noa Noa (Perfume)

1893/94

18b. Night (Te po)

1893/94

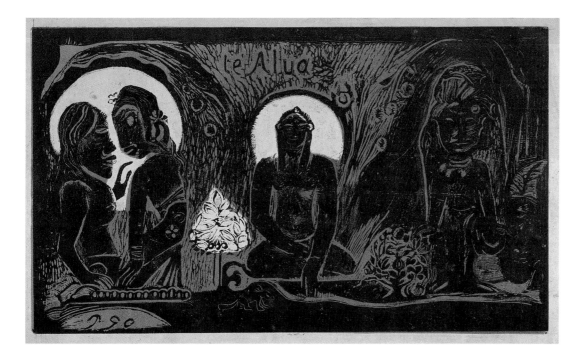

*19a. The Gods
(Te atua)*
1893/94

*19b. The Universe
Is Created
(L'Univers est crée)*
1893/94

20a. Offerings of Gratitude (Maruru)
1893/94

20b. The Delightful Land
(Nave nave fenua)
1893/94

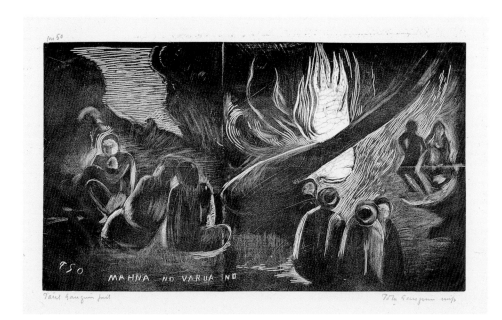

21a. The Devil Speaks (Mahna no varua ino)
1893/94

21b. Here We Make Love
(Te faruru)
1893/94

22a. Women at the River/Sea (Auti te pape)
1893/94

22b. The Spirit of the Dead Watches (Manao tupapau)
1893/94

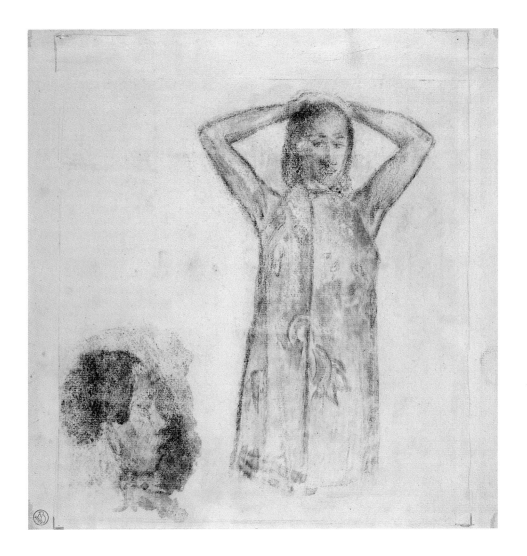

23. Tahitian Girl in a Pink Pareu

1894

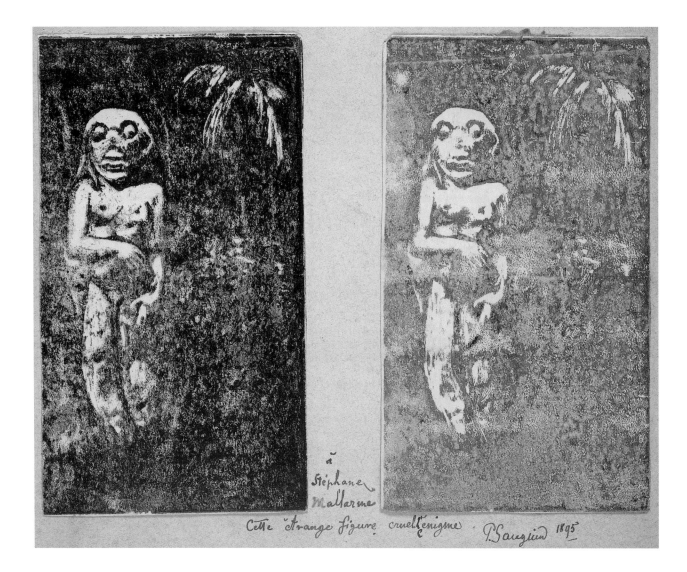

24. Oviri

1894 (signed 1895 on secondary support)

25. Why Are You Angry? (No te aha oe riri)

1896

26. Change of Residence

1898-99

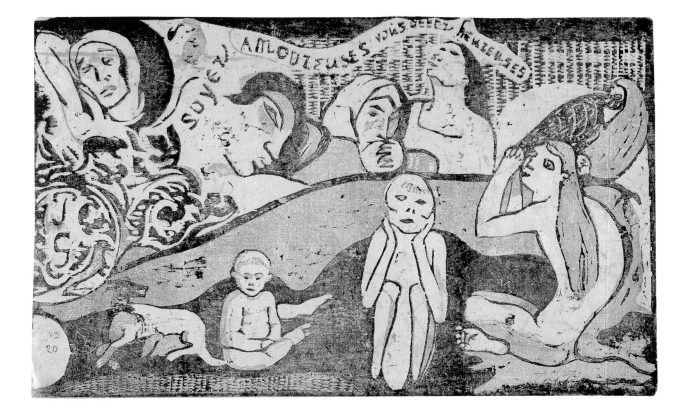

27. Be In Love and You Will Be Happy (Soyez amoureuses, vous serez heureuses)
1898-99

28. Fisherman Kneeling beside His Dugout Canoe

c. 1898

29. Still Life with Cat

c. 1899

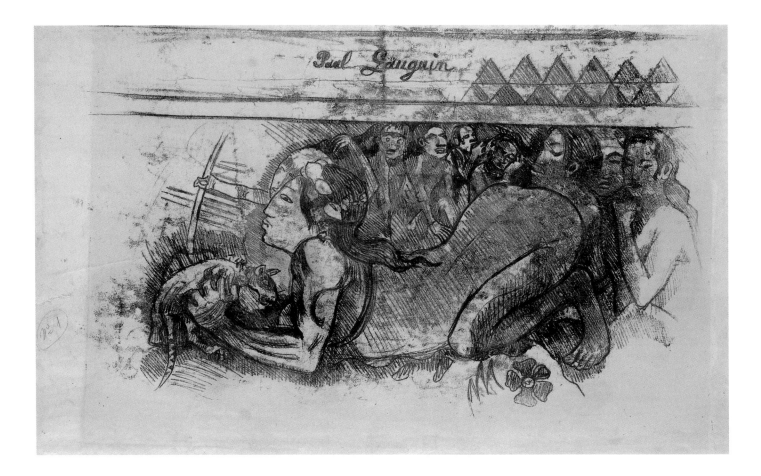

30. Untitled (known as *Woman with a Cat* and *Crouching Tahitian Woman*)
1899/1902

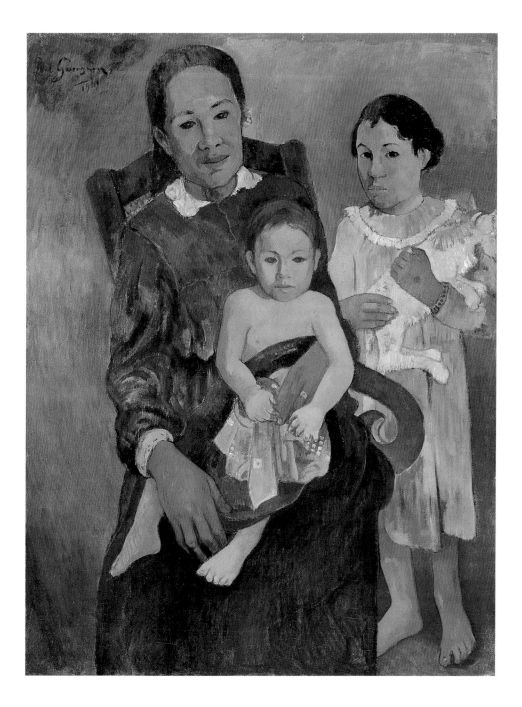

31. Woman with Children

1901

32. Nativity (Mother and Child Surrounded by Five Figures)

1902

Checklist

1. *Jean René Gauguin*
 1881
 Brush and brown wash with pen and brown
 ink and red chalk on cream wove paper;
 11.9 x 12.2 cm
 The H. Karl and Nancy von Maltitz
 Endowment, 1990.63
 Ill. p. 72

2. *Wood Tankard and Metal Jug*
 1880
 Oil on canvas; 52.1 x 62.9 cm
 Millennium Gift of Sara Lee Corporation,
 1999.362
 Ill. p. 73

3. *The Faun*
 1886
 Unglazed stoneware with touches of gold;
 47 x 29.9 x 27.3 cm
 Estate of Suzette Morton Davidson; Major
 Acquisitions Centennial, 1997.88
 Ill. p. 74, detail p. 13

4. *Seated Breton Woman*
 1886
 Charcoal and pastel selectively worked with
 brush and water on ivory laid paper;
 32.8 x 48.3 cm
 The Mr. and Mrs. Carter H. Harrison
 Collection, 1933.910
 Ill. p. 75

5. *Breton Bather*
 1886–87
 Black chalk and pastel squared in black chalk
 on cream laid paper; 58.8 x 35.8 cm
 (sheet irregularly cut)
 Gift of Mrs. Charles B. Goodspeed, 1946.292
 Ill. p. 76

6. *Arlésiennes (Mistral)*
 1888
 Oil on canvas; 73 x 92 cm
 Mr. and Mrs. Lewis Larned Coburn Memorial
 Collection, 1934.391
 Ill. p. 77, detail p. 21

7a. *Arlésiennes (Mistral)*, plate 9 from *Dessins lithographiques*, known as the *Volpini Suite*
1889
Zincograph in black on yellow wove paper; image 19.6 x 20.9 cm; sheet 49.9 x 65 cm
William McCallin McKee Endowment Collection, 1943.1021
Ill. p. 78

7b. *Dramas of the Sea, Brittany*, plate 2 from the *Volpini Suite*
1889
Zincograph in black on yellow wove paper; image 16.7 x 22.6 cm; sheet 49.8 x 64.9 cm
William McCallin McKee Endowment Collection, 1943.1026
Ill. p. 79

8. *Portrait of a Woman in Front of a Still Life by Cézanne*
1890
Oil on canvas; 65.3 x 54.9 cm
Joseph Winterbotham Collection, 1925.753
Ill. p. 80, detail p. 71

9. *Page from a Tahitian Sketchbook Featuring a Pandanus Leaf, a Seated Tahitian Woman Weaving Pandanus Leaves, the Same Figure in Profile, and a Vanilla Plant*
1891/93
Black crayon, graphite, and brush and water-color on cream wove paper; 31.2 x 20.1 cm
Gift of Mr. and Mrs. Morton G. Neumann, 1966.545
Ill. p. 81

10. *The Big Tree (Te raau rahi)*
1891
Oil on canvas; 73 x 91.4 cm
Gift of Kate L. Brewster, 1949.513
Ill. p. 82

11. *The Hibiscus Tree (Te burao)*
1892
Oil on canvas; 68 x 90.7 cm
Joseph Winterbotham Collection, 1923.308
Ill. p. 83, detail p. 27

12. *Heads of Tahitian Women, Frontal and Profile Views* (recto and verso)
1891/93
Charcoal selectively stumped and worked with brush and water, fixed, on ivory wove paper; 41.4 x 32.6 cm
Gift of David Adler and His Friends, 1956.1215 (recto and verso)
Ill. p. 84

13. *Tehamana Has Many Parents (Merahi metua no Tehamana)*
1893
Oil on canvas; 76.3 x 54.3 cm
Gift of Mr. and Mrs. Charles Deering McCormick, 1980.613
Ill. p. 85, details frontispiece and p. 35

14. *Crouching Tahitian Woman: Study for "When Will You Marry? (Nafea faaipoipo)"*
1892
Pastel and charcoal over preliminary drawing in charcoal, selectively stumped, and squared with black chalk, on tan wove paper; 55.5 x 48 cm
Gift of Tiffany and Margaret Day Blake, 1944.578 (recto)
Ill. p. 86

15. *Two Sketches of a Tahitian Woman and a Marquesan Earplug*
1891/93
Reed pen and metal pen and brown ink and graphite on vellum; 24 x 31.7 cm
David Adler Memorial Fund, 1950.1413
Ill. p. 87

16. *Day of the God (Mahana no atua)*
1894
Oil on canvas; 68.3 x 91.5 cm
Helen Birch Bartlett Memorial Collection, 1926.198
Ill. p. 88, details pp. 41 and 48, and cover

17. *Mysterious Water (Papa moe)*
1893/94
Watercolor on ivory wove paper;
35.2 x 25.5 cm
Gift of Mrs. Emily Crane Chadbourne, 1922.4797
Ill. p. 89, detail p. 55

18a. *Noa Noa (Perfume)*
1893/94
Woodcut from the endgrain of a boxwood block, in black and gray on ivory China paper; image 35.5 x 20.6 cm; sheet 42.2 x 26.6 cm
Gift of the Print and Drawing Club, 1924.1197
Ill. p. 90

18b. *Night (Te po)*
1893/94
Woodcut from the endgrain of a boxwood block, in black and gray on ivory China paper; image 20.5 x 35.8 cm; sheet 26.6 x 42.6 cm
Gift of the Print and Drawing Club, 1924.1199
Ill. p. 90, detail p. 61

19a. *The Gods (Te atua)*
1893/94
Woodcut from the endgrain of a boxwood block, in black over red ink on thick tan Japanese vellum paper; 20.4 x 35.5 cm
Print Department Fund, 1943.527
Ill. p. 91

19b. *The Universe Is Created (L'Univers est crée)*
1893/94
Woodcut from the endgrain of a boxwood block, in black and gray on ivory China paper; image 20.4 x 35.4 cm; sheet 26.8 x 42.7 cm
Gift of the Print and Drawing Club, 1924.1203
Ill. p. 91

20a. *Offerings of Gratitude (Maruru)*
1893/94
Woodcut from the endgrain of a boxwood block, in black and gray on ivory China paper; image 20.4 x 35.6 cm; sheet 26.8 x 42.7 cm
The Joseph Brooks Fair Collection and gift of the Print and Drawing Club, 1924.1200
Ill. p. 92

20b. *The Delightful Land (Nave nave fenua)*
1893/94
Woodcut from the endgrain of a boxwood block, in black and gray on ivory China paper; image 35.45 x 20.4 cm; sheet 42.2 x 26.8 cm
Gift of the Print and Drawing Club, 1924.1201
Ill. p. 92

21a. *The Devil Speaks (Mahna no varua ino)*
1893/94
Woodcut from the endgrain of a boxwood
block, in black and gray on ivory China paper;
image 20.3 x 35.4 cm; sheet 26.7 x 42 cm
The Joseph Brooks Fair Collection, 1924.1196
Ill. p. 93

21b. *Here We Make Love (Te faruru)*
1893/94
Woodcut from the endgrain of a boxwood
block, in ocher and black on cream Japanese
paper stained prior to printing with various
hand-applied and transferred watercolors and
waxy media; 35.8 x 20.5 cm
Clarence Buckingham Collection, 1950.158
Ill. p. 93

22a. *Women at the River/Sea (Auti te pape)*
1893/94
Woodcut from the endgrain of a boxwood
block, in black and gray on ivory China paper;
image 20.5 x 35.5 cm; sheet 27 x 41.8 cm
Albert Roullier Memorial Collection, 1926.96
Ill. p. 94

22b. *The Spirit of the Dead Watches (Manao
tupapau)*
1893/94
Woodcut from the endgrain of a boxwood
block, in black and gray on ivory China paper;
image 20.5 x 35.6 cm; sheet 27.2 x 43.3 cm
The Joseph Brooks Fair Collection, 1924.1198
Ill. p. 94

23. *Tahitian Girl in a Pink Pareu*
1894
Counterproof from a gouache matrix on ivory
laid paper; 27.5 x 26.8 cm
Gift of Walter S. Brewster, 1949.606
Ill. p. 95

24. *Oviri*
1894 (signed 1895 on secondary support)
Woodcut in brown and black on cream
Japanese paper hinged at top corners together
with 47.686.2 on light-blue card discolored to
tan with blue fibers; 20.8 x 12 cm
Print and Drawing Department Funds,
1947.686.1
Ill. p. 96

Woodcut in brown and black on cream Japanese
paper hinged at top corners together with
47.686.1 on light-blue card discolored to tan
with blue fibers; 20.7 x 12 cm
Print and Drawing Department Funds,
1947.686.2
Ill. p. 96

25. *Why Are You Angry? (No te aha oe riri)*
1896
Oil on canvas; 95.3 x 130.5 cm
Mr. and Mrs. Martin A. Ryerson Collection,
1933.1119
Ill. p. 97, detail p. 67

26. *Change of Residence*
 1898–99
 Woodcut in black, pasted down over an
 impression of a first state in ocher on cream
 Japanese paper; 16.3 x 30.5 cm
 Albert H. Wolf Memorial Collection, 1939.322
 Ill. p. 98

27. *Be in Love and You Will Be Happy (Soyez
 amoureuses, vous serez heureuses)*
 1898–99
 Woodcut in black, pasted down over an
 impression of a first state in ocher on cream
 Japanese paper; 16.2 x 27.6 cm
 Joseph Brooks Fair Collection, 1949.932
 Ill. p. 99

28. *Fisherman Kneeling beside His Dugout Canoe*
 c. 1898
 Woodcut in black and handcolored in red,
 orange, pink, yellow, and slate gray on cream
 Japanese paper; 20.6 x 14.1 cm
 Clarence Buckingham Collection, 1971.785
 Ill. p. 100

29. *Still Life with Cat*
 c. 1899
 Watercolor on ivory laid paper; 63.2 x 36 cm
 Gift of Helen Tieken Geraghty in memory of
 Dr. and Mrs. Theodore Tieken, 1981.409
 Ill. p. 101, detail p. 8

30. *Untitled* (known as *Woman with a Cat* and
 Crouching Tahitian Woman)
 1899/1902
 Transfer drawing in brownish-black ink
 (recto); graphite and blue crayon pencil with
 brush and solvent washes in ocher (verso) on
 cream wove paper; 30.5 x 50.8 cm
 Through prior bequest of the Mr. and Mrs.
 Martin A. Ryerson Collection,
 1991.217 (recto and verso)
 Ill. p. 102

31. *Woman with Children*
 1901
 Oil on canvas; 97.2 x 74.3 cm
 Helen Birch Bartlett Memorial Collection,
 1927.460
 Ill. p. 103, detail p. 106

32. *Nativity* (*Mother and Child Surrounded by
 Five Figures*)
 1902
 Transfer drawing in black and brown ink
 (recto); graphite and brown crayon pencil
 (verso) on cream wove paper; 24.3 x 22.2 cm
 Gift of Robert Allerton, 1922.4317
 Ill. p. 104

Selected Bibliography

Bodelsen, Merete. *Gauguin's Ceramics: A Study in the Development of His Art*. London, 1964.

Brettell, Richard. *Post-Impressionists*. Chicago and New York, 1987.

Brettell, Richard, et al. *The Art of Paul Gauguin*. Washington D. C. and Chicago, 1988.

Druick, Douglas W., and Peter Kort Zegers. *Paul Gauguin: Pages from the Pacific*. Auckland, 1995.

———. *Vincent van Gogh and Paul Gauguin: The Studio of the South*. Chicago, Amsterdam, and New York, 2001.

Gauguin, Paul. *The Intimate Journals of Paul Gauguin*. Trans. by Van Wyck Books; preface by Émile Gauguin. London, 1923; reprint, London, 1985.

———. *Noa Noa*. Trans. by O. F. Theis. New York, 1920.

Gray, Christopher. *Sculpture and Ceramics of Paul Gauguin*. Baltimore, 1963; reprint, New York, 1980.

Guérin, Marcel. *L'Oeuvre gravé de Gauguin*. Paris, 1927; rev. ed., San Francisco, 1980.

Pickvance, Ronald. *Gauguin*. Martigny: Switzerland, 1998.

Thomson, Belinda. *Gauguin*. London, 1987.

———, ed. *Gauguin by Himself*. Boston, 1993.

Wildenstein, Georges. *Gauguin*. Ed. by Raymond Cogniat and Daniel Wildenstein. Vol. 1: Catalogue. Paris, 1964.